ALLOWED TO GROW OLD

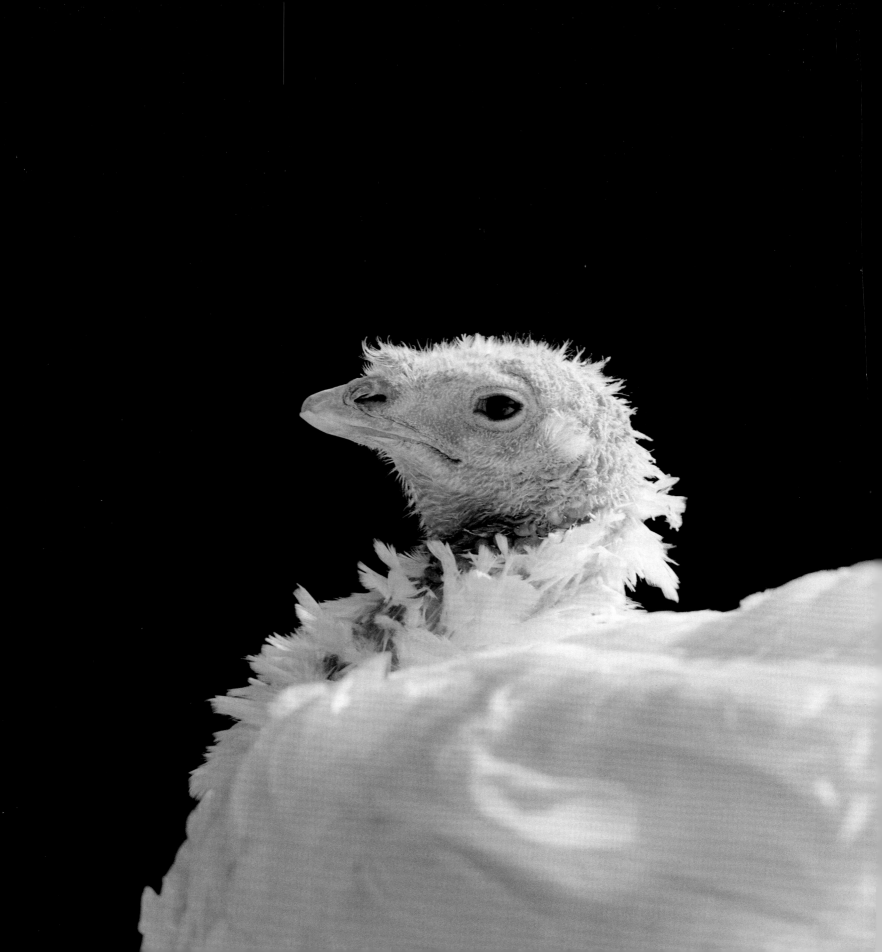

# Allowed to Grow Old

PORTRAITS OF ELDERLY ANIMALS FROM FARM SANCTUARIES

## Isa Leshko

FOREWORD BY SY MONTGOMERY

ESSAYS BY GENE BAUR AND ANNE WILKES TUCKER

The University of Chicago Press | Chicago and London

The University of Chicago Press, Chicago 60637

The University of Chicago Press, Ltd., London

© 2019 by Isa Leshko

Published 2019

Printed in Canada

28  27  26  25  24  23  22  21  20  19      1  2  3  4  5

ISBN-13: 978-0-226-39137-3 (cloth)

ISBN-13: 978-0-226-39140-3 (e-book)

DOI: https://doi.org/10.7208/chicago/9780226391403.001.0001

Library of Congress Cataloging-in-Publication Data

Names: Leshko, Isa, 1971– author, photographer. | Montgomery, Sy, writer of
        foreword. | Baur, Gene, author. | Tucker, Anne, author.
Title: Allowed to grow old : portraits of elderly animals from farm sanctuaries /
        Isa Leshko ; photographs by Isa Leshko ; foreword by Sy Montgomery ; essays
        by Gene Baur and Anne Wilkes Tucker.
Description: Chicago : The University of Chicago Press, 2019. | Includes
        bibliographical references.
Identifiers: LCCN 2019000618 | ISBN 9780226391373 (cloth : alk. paper) |
        ISBN 9780226391403 (e-book)
Subjects: LCSH: Domestic animals—Pictorial works. | Animal sanctuaries—United
        States. | Domestic animals—United States—Biography. | Animal rights.
Classification: LCC HV4757 .L47 2019 | DDC 179/.30973—dc23
LC record available at https://lccn.loc.gov/2019000618

♾This paper meets the requirements of ANSI/NISO Z39.48-1992
(Permanence of Paper).

For the animals
who never make it to sanctuaries
and for those working tirelessly
on their behalf

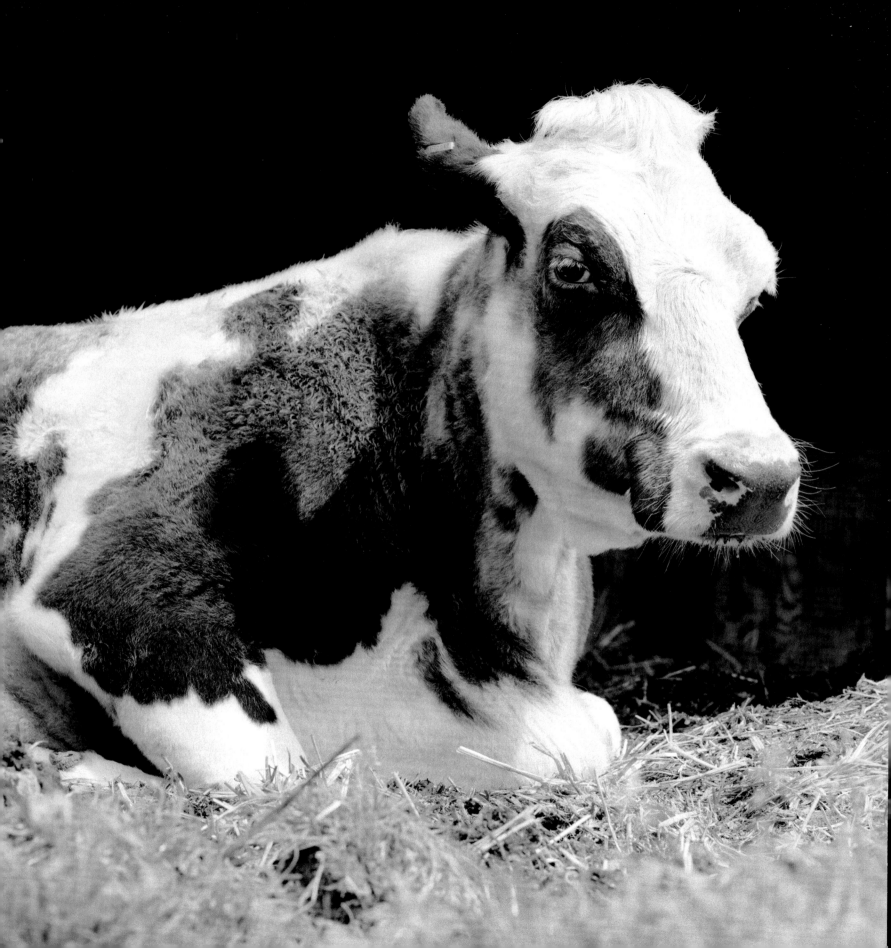

I think I could turn and live with animals,

they are so placid and self-contain'd,

I stand and look at them long and long.

WALT WHITMAN

Silently the animal catches our glance. The animal looks at us,
and whether we look away (from the animal, our plate, our
concern, ourselves) or not, we are exposed. Whether we change
our lives or do nothing, we have responded. To do nothing is to
do something.

JONATHAN SAFRAN FOER

# Contents

Foreword BY SY MONTGOMERY XI

Introduction BY ISA LESHKO 3

List of Sanctuaries Visited 15

Plate Gallery 17

Animal Stories BY ISA LESHKO 89

What Farm Sanctuaries Teach Us BY GENE BAUR 99

Empathy That Became Advocacy BY ANNE WILKES TUCKER 103

Notes 109

Suggested Reading 117

Author and Contributor Biographies 121

Acknowledgments 123

# Foreword

SY MONTGOMERY

Isa Leshko's images of aging animals show individuals near the ends of eventful lives. All the animals photographed in this book were, at one point, unwanted. Many of these animals—goats and turkeys, chickens and pigs, sheep and cows, horses and dogs—were victims of abuse. Many more suffered from neglect. Some were found wandering the streets after escaping from trucks en route to the slaughterhouse. All were rescued. All of them survived to old age because someone understood that these creatures love their lives as we love our own.

The individuality of each animal shines forth in each portrait in this book. Those of us who have lived with cats and dogs know each is distinctly different. But what about chickens? What about sheep? Many people unfamiliar with these animals underestimate their intelligence and deny them individuality. Perhaps two reasons for this mistake are these: farm animals often live in large groups, and we just see a crowd. Equally important, the point at which a human observes them is often stressful for the animals. Nobody's personality shines forth as distinct when everybody is scared. Yet it is at this point—when an animal is approached by a frightening intruder, one who is pointing a big black eye at them and popping blinding flashes of light—that many animals are photographed. This doesn't show us who an animal is at all.

Isa took a different tack. She approached her animal subjects humbly, giving each time to get used to her, returning again and again till they were calm in her presence. Isa took the portraits at the subjects' own eye level, approaching them as if she were a fellow sheep or duck or pig. She avoided flash, using only available light. It took Isa nine years to complete these photographs.

And what do they reveal? These are individuals with knowledge and memories. They have seen people come and go. They've seen friends and sometimes their own children die and be taken away. They remember their friends—as we know from watching joyous reunions of animals and people who have been apart for years. They remember abuse and neglect. They also seem to understand they are safe now. You can see this in their faces.

Another thing you see in these faces: Animals, like people, can grow wise with age. They become finished and complete. Which brings us to the subject of grace.

Most human and nonhuman animals embody physical grace in their youth and are elegant, effortless, and refined in their movements. Most of us lose some of

this in old age. But we may gain a different grace, the kind with which we bless our meals, the kind to which we appeal when we need the excellence and power of a greater-than-human origin. Grace is also, theologians tell us, the power to regenerate and sanctify, inspire and strengthen.

This grace is evident in every photograph in this collection. I'll mention just one (p. 8): two arthritic Finnsheep are lying in the doorway of their barn. They've been napping contentedly next to each other and have just woken up. The photo feels as intimate as touch. It recalls for me the golden hours I spent with Christopher Hogwood, our pig, in the final summer of his fourteen-year life. He had a little bit of arthritis, and some porcine pattern baldness by then, but in his old age had attained both gravitas (at 750 pounds!) and grace. He had always loved gentle touch, especially belly rubs and warm baths. But these gentle pleasures took on greater importance to him, I think, once he outgrew the excitability and athleticism of his youth. In his elder years he seemed to especially relish the times we would simply lie beside one another in the green grass, bathing in the sunshine, the scents of the barnyard and orchard, and the glow of each other's affection.

There are people who say that once animals grow old, they're better off euthanized. I know that's not true. I know it because of my father, who unlike these animals, could speak. He had been a prisoner of war and was a survivor of the Bataan Death March. He would have understood what some of the farm animals in this book had been through before they, like him, were liberated. He was an athletic man who loved golf, tennis, swimming, dance; he loved good food and music and travel to exotic countries. But there were times, he said, that he would purposely let his thirst grow sharp, just so he could better enjoy a pleasure he was denied in prison camp: a simple sip of cool water.

When my father developed cancer in his 70s, he could no longer enjoy travel or golf, swim or dance. Chemo killed his taste buds and dulled his hearing. But there was always the joy of a sip of cool water. There was the comfort of being with his wife and his daughter. I was with him when he died, and up to the last second, he was fighting for one last moment of this beautiful life.

The company of a friend. The warmth of the sun. A sip of cool water. It's not just enough; it's glorious. It's all that really matters, and it's all that ever mattered. This is what the animals in these pages know. This is what Isa's photos show us. Perhaps, as well, they will teach us something just as glorious: that we humans

have the power to let animals live out their precious lives until they are finished and complete. When we learn to do so, perhaps our kind will have attained the grace that you can see on these faces—and realize that farm animals are as worthy of our love and respect as are our companion animals and our fellow humans.

ALLOWED TO GROW OLD

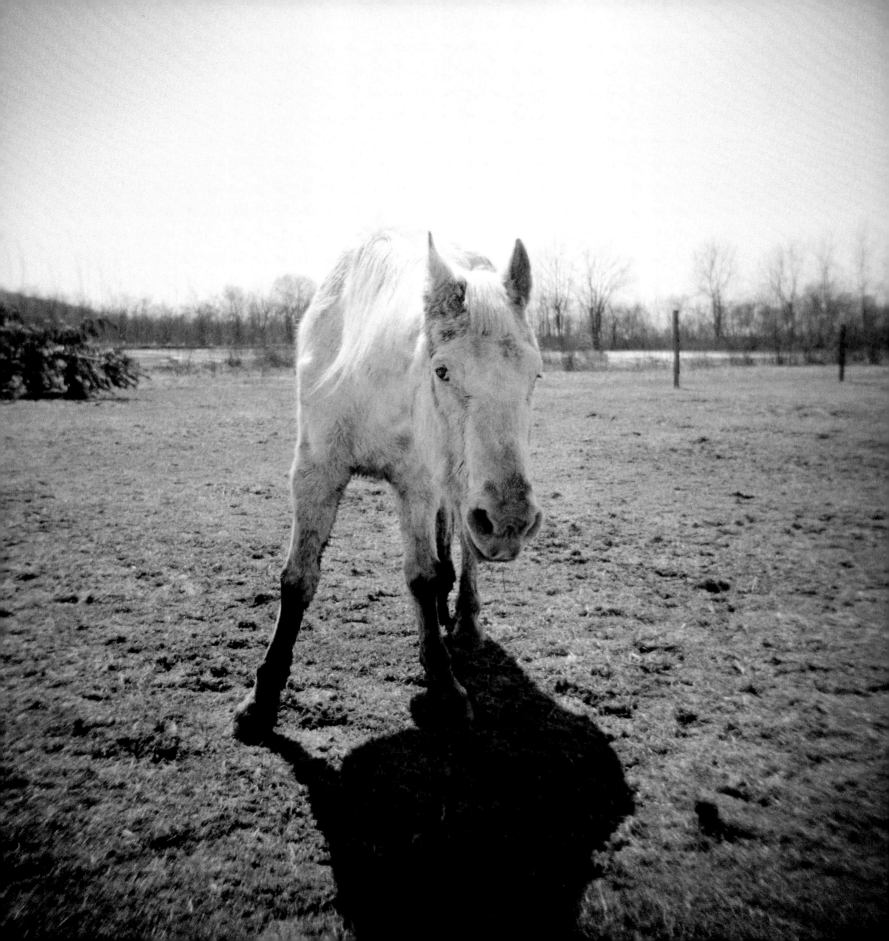

# Introduction

ISA LESHKO

New Jersey was the last place I expected to meet a horse who would change my life. I had grown up along the state's "Chemical Coast," a stretch of the Turnpike where the air is so pungent you close the vents in your car as you drive through it. From my childhood bedroom, I used to gaze at the Port Reading Oil Refinery off in the distance. By day, I was captivated by the cottony puffs of smoke billowing from its stacks. By night, its glowing orange sign was my neon North Star. At the end of the Turnpike off-ramp for our town, travelers were greeted by a sign, "Welcome to Carteret: a proud community on the move!" Whenever my sister Mia and I passed it, we declared in unison that Carteret was a proud community that should *be* moved.

Instead, we were the ones who moved. After graduating college, I migrated to New England and my sister relocated to a more bucolic section of New Jersey. When I visited Mia in 2008, she invited me to dinner at her brother-in-law's home. She knew that I love animals and thought I would enjoy seeing Todd and MariJo's horses. As soon as we reached their house, my 11-year-old niece Francesca and her cousins bolted to the field where the horses were grazing. Feeling shy, I headed outside as well.

That's when I met Petey, a 34-year-old Appaloosa horse. He had deep hollows above his cataract-laden eyes and his back had a pronounced sway. His coat was dull and coarse. Though he moved stiffly, he followed us as we walked around the pasture. He was gentle with the children and seemed unfazed by their frenetic movements. I was mesmerized by this beautiful animal and ran back into the house to grab my Holga, a toy film camera that was the only gear I had with me. Long after the kids had gone inside, I remained with Petey. I wasn't sure why I was so drawn to him, but I kept taking pictures.

It had been a long time since I felt this kind of excitement while holding a camera. For several years, my sister and I had been caring for both of our elderly parents. In a span of eighteen months, Dad had successfully battled stage IV oral cancer and Mom had become delusional and at times violent due to her advanced Alzheimer's disease. After a series of crises, we decided as a family that Mom was safest in a skilled nursing facility with a dementia-care unit. Finding the right place for her and easing her transition to her new home consumed my energies for several months.

Petey, an Appaloosa horse, age 34

When I reviewed my negatives from my afternoon with Petey, I realized I had stumbled upon a way to examine my grief and fear stemming from Mom's illness, and I knew I had to find other elderly animals to photograph. I wasn't thinking about embarking on a long-term project. I was seeking catharsis.

I searched for local animal sanctuaries and discovered Winslow Farm in Norton, Massachusetts, only two hours from my house. The sanctuary had two senior Finnsheep named Zebulon and Isaiah and an ancient Embden Goose named Blue whom I photographed several times that fall. Like many Americans, I had never before spent time with farm animals. Although animal-derived products are ubiquitous in this country, farm animals themselves are removed from our daily lives. This realization compelled me to learn more about these animals and photograph them. Through online research, I discovered other farm animal sanctuaries across the country and began visiting them.

The animals at these sanctuaries come from a variety of situations. Some are found wandering the streets after they've escaped from trucks en route to slaughterhouses. Others are rescued from hoarders or backyard butcher operations that got out of control. Many are abandoned during natural disasters or when farmers can no longer afford to feed them.[1] On rare occasions, the animals are beloved pets whose humans can no longer care for them. Most animals, though, come from dire situations. They tend to arrive at sanctuaries gravely ill and require extensive veterinary care. Some do not survive, but the ones who do are given a home for the rest of their lives.

At these sanctuaries, animals are given ample space to roam freely and indulge their natural behaviors. Chickens spend their days outdoors basking in the sun and taking dust baths. Their living conditions are vastly different from those of industry chickens who are densely packed in poorly ventilated, windowless sheds.[2] On commercial farms, sows are so tightly confined that they can't even turn around.[3] At sanctuaries, pigs explore large pastures and soak in wallows. They sleep curled up together on fresh hay, often snoring loudly.

Nothing is expected of these animals.[4] Many sanctuaries offer guided educational tours, but the animals determine how much (or how little) contact they have with visitors. Humans do not consume any products derived from the animals who live at these sanctuaries. Although sheep are sheared for their comfort during the hot months, their wool is left outside for birds to claim for nesting material. Eggs

Welcome sign at Pasado's Safe Haven
in Sultan, Washington

are boiled, crushed, and fed back to hens as a calcium supplement. Animals at sanctuaries are either sterilized or segregated by sex to prevent breeding, but occasionally pregnant animals are rescued. Any milk they produce is consumed only by their babies, who remain with them throughout their lives.[5] In his essay for this book, activist Gene Baur writes about cofounding Farm Sanctuary, one of the oldest sanctuaries for farm animals in the world. I visited Farm Sanctuary's shelters in Orland, California, and Watkins Glen, New York, several times while working on this project.[6]

It must be said that not all farm sanctuaries are as well-run as the ones I visited for my project. Although many states require animal shelters to obtain health department licenses and zoning permits, regulations are lax (or nonexistent) regarding the care of farm animals. Furthermore, most state animal cruelty laws do not protect farm animals.[7] The Global Federation of Animal Sanctuaries provides a rigorous accreditation program for farm sanctuaries.[8] But participation is voluntary, and many smaller sanctuaries lack the resources to meet GFAS's high standards. (That does not mean they are poorly run. There are many excellent sanctuaries that are not accredited by GFAS, including several I visited for my project.) Nonetheless there are places that call themselves sanctuaries where animals live in deplorable conditions. Some of these "sanctuaries" are petting zoos that do not properly care for their animals and dispose of them when they grow sick or old. Others are founded by idealists who lack the expertise and finances to operate a sanctuary and quickly get in over their heads.[9] For this project, I met several animals who had been rescued from poorly run sanctuaries, including Cecil, a La Mancha/Saanen crossbreed (see plate 43).

||

At what age are rescued farm animals considered old? I struggled with this question. On today's factory farms, animals are bred to reach slaughter weight at a younger age than ever before. What constitutes slaughter weight also has

increased significantly over the past ninety years. In 1925, chickens raised and used for meat (commonly referred to as "broilers") lived for approximately 112 days before they were slaughtered. Chickens at that age weighed around 2.5 pounds, which means it took them an average of 44.8 days to gain each pound. Fast forward to 2017: broiler chickens are now slaughtered at only 47 days old, at which point they weigh 6.18 pounds. That's a growth rate of nearly a pound per week.[10]

It's difficult to fully appreciate how unnatural this rapid and extreme growth is until you compare commercially raised animals with their wild counterparts. Factory farm turkeys are slaughtered at three to four months old but can live up to ten years in the wild. A wild male turkey weighs approximately 7.7 pounds at four months of age; commercial male turkeys weigh more than three times this amount (25 pounds) at the same age.[11] At the time of their deaths, male domestic turkeys weigh approximately 31 to 36 pounds compared with wild toms who weigh on average 17 to 21 pounds. Domestic hens weigh 13 to 17 pounds when they are slaughtered, whereas wild hens weigh on average 8 to 11 pounds.[12]

Rescued farm animals often grapple with health problems related to their breeding and early confinement. When factory farm animals are young, their weight gain often outpaces their bone development. Their still-growing bones have difficulty supporting their obese bodies. At the time of their rescue, many farm animals are lame due to broken bones, skeletal deformities, or torn ligaments. Once they are rescued, they receive excellent medical care and frequently make miraculous recoveries. But, often, these animals have arthritis and other orthopedic problems that plague them throughout their lives. Other common health problems include pulmonary hypertension, heart disease, and various cancers.

Residents at well-run sanctuaries are routinely seen by veterinarians and receive surprisingly sophisticated medical care. Many facilities are situated near top-tier veterinary schools, which allows sanctuary staff to consult with specialists like cardiologists, orthopedists, and oncologists. These schools welcome the opportunity to work with rescued farm animals because doing so often leads to new scientific discoveries. Farm animals typically do not live long enough to develop chronic illnesses, so very little is known about how to treat them. On commercial farms, the cost of veterinary care cuts into the bottom line. Sick animals are either killed or left to die.

When sanctuary animals get sick, they are given constant care. Staff members routinely sleep next to the animals during particularly difficult nights. Each animal is regularly assessed in terms of her quality of life. When euthanasia is considered the most humane course of action, it is performed while the animal is surrounded by her closest human and animal companions.

Sanctuary staff often develop close bonds with the animals in their care and mourn their deaths.[13] Some preserve locks of fur, feathers, or other tokens from animals they have loved. Others get tattoos honoring deceased animals with whom they were especially close. Some sanctuaries hold memorial services during which ashes of the dead are scattered or buried. Several have gardens that contain stones carved with the names of departed residents.[14] Most sanctuaries also publish obituaries for recently deceased animals on their blogs and social media accounts.

III

From the earliest stages of this project—before I even thought of it as a project—I intuitively approached these images as portraits. During my first visit to Winslow Farm, I encountered Zebulon and Isaiah, two Finnsheep who had severe arthritis and spent most of their days napping next to each other. I spotted them lying in a barn doorway, their faces lit by the warm September sun. I walked toward them cautiously, not sure what would happen. They seemed calm so I inched forward. Again, they did not stir. I dropped to the ground so I could gaze into their eyes directly while photographing them. It seemed natural to take this approach, so I employed it for the remainder of the project. I have spent countless hours lying in mud and animal scat in pursuit of pictures. By the end of a day spent in a barnyard, I am filthy, sweaty, and sometimes covered in mites. My muscles and joints ache from contorting my body to remain at eye-level with the animals I photograph. I feel every bit as old as the animals I met that day.

Not every photo session went as smoothly as my first one with Zebulon and Isaiah. Rescued farm animals are often wary of strangers. Gaining their trust is essential. Before taking any photos, I often lie on the ground near the animal to help him acclimate to my presence. Sometimes it takes several days to develop a

comfortable rapport, and some animals never warm up to me. Although animals are unable to offer photographic consent, they are adept at communicating that they wish to be left alone. If an animal seems unnerved by my presence, I immediately retreat. To continue taking pictures would be exploitative.[15]

I have never been comfortable with the power imbalance that exists between the photographer and her subject. Although those in front of the camera control their facial expressions and gestures, the photographer determines what is in the frame and when precisely to click the shutter. The photographer also retains power long after a portrait session is over because she selects which image(s) to print (or publish online) and how those images should look. In her book *On Photography*, Susan Sontag writes, "To photograph people is to violate them, by seeing them as they never see themselves, by having knowledge of them that they can never have."[16]

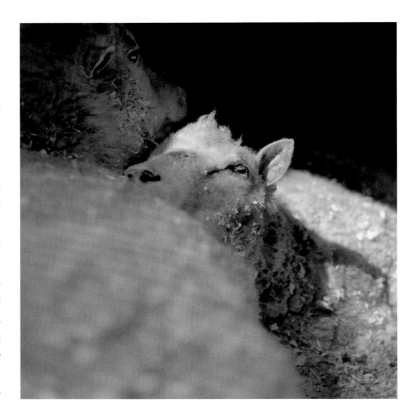

Zebulon and Isaiah, Finnsheep, both age 12

Photography's long association with hunting further casts picture-taking in a predatory light. Beginning in the second half of the nineteenth century, hunters photographed carcasses of animals they had killed to exhibit as trophies.[17] (This practice still exists today as evidenced by the photo of Donald Trump's sons posing with a slain leopard that went viral online during the summer before the 2016 presidential election.) After Ottomar Anschütz developed the focal plane shutter in the late 1880s, cameras became fast enough to record animals in motion. By the next decade, photographing wildlife became a popular pastime known as *camera hunting*.[18] Conservationists during that era billed this pursuit as a sport that required more skill than traditional hunting. Camera hunting did not replace actual hunting during that era, however, and often animals were killed shortly after they had been photographed.[19] This history is why we talk about cameras as though they were guns: when you take a picture, you aim your camera at your subject and you shoot it. I had never considered the violent connotations of this jargon until I began photographing animals. The first time I asked a sanctuary director whether I could shoot her elderly residents, I turned bright crimson. We both laughed, but I vowed to never use that term again.

My favorite portraitists are sensitive to the vulnerability of their subjects and take steps to empower them during photo sessions. Shelby Lee Adams has spent nearly four decades documenting the people of rural Appalachia. He doesn't view the people he photographs as subjects; he thinks of them as collaborators.[20] While working, he routinely takes Polaroids to share with them and solicits their feedback. I obviously cannot partner with animals in this way, but I can maximize their comfort when I photograph them. For this reason, I photograph animals in their own environments so they will be more relaxed. I also keep my equipment to the bare minimum so it is not threatening to them. I work only with available light, which can be challenging in dimly lit barns. I have tried using reflectors, but they distract many animals (especially goats, who like to chew on them). I generally do not even use a tripod and instead stabilize my camera on my knee or on the ground. My job certainly would have been simpler had I photographed animals in a studio setting. But taking this approach would have forced them to meet me on my terms instead of theirs.

## IV

Another reason I admire Adams's work is that it is devoid of sentimentality. He does not romanticize the poverty in which his subjects live nor does he exploit stereotypes about poor people living in Appalachia. When I embarked on this project, I was aware that my photos of old animals could easily become maudlin if I was not careful. I was also mindful of the bias against animal-themed photography that exists in the art world. "Consider, for instance, what has come in our century to be regarded as that most kitsch of all subjects: *animals* in art," writes art historian Steve Baker in *Picturing the Beast: Animals, Identity, and Representation*. "The many lavish coffee-table volumes devoted to the subject are viewed with disdain by the professional eye, the discriminating eye, the eye of the typical art historian."[21] This view was echoed by a few trusted advisers who discouraged me from pursuing this project when I first told them about it. They feared that curators and major collectors would stop taking me seriously if I photographed animals.[22]

One of my influences for this project is the memoir *Dog Days*, Mark Doty's beautifully written account of caring for his two aging dogs, Beau and Arden. As I read it the first time, I wondered whether any of Doty's friends had tried to dissuade

him from writing a book about dogs. I might be projecting, but I detected a note of defensiveness in this early passage from the book: "Sentimental images of children and of animals, sappy representations of love—they are fueled, in truth, by their opposites, by a terrible human rage that nothing stays. The greeting card verse, the airbrushed rainbow, the sweet puppy face on the fleecy pink sweatshirt—these images do not honor the world as it is, in its complexity and individuality, but distort things in apparent service of a warm embrace." With these searing words, Doty promises readers (and perhaps himself) that he will chronicle Beau and Arden's decline and inevitable deaths with resolute honesty.

I made a similar vow when I started this project. Before my first visit to Winslow Farm, I carefully considered which camera to bring with me. Upon reviewing my negatives from my afternoon with Petey, I knew instantly that my Holga—a plastic camera that produces soft, dream-like images—was the wrong choice for this work. I considered bringing a view camera that uses 4-by-5-inch sheet film, but realized it was an impractical setup for photographing animals. I finally opted for my Hasselblad 503 CW, a medium-format film camera that is considerably more portable but still creates richly detailed images.

Although I wanted my images to be unflinching in their detail, I did not want them to feel cold, or worse, cruel. To invite intimacy, I photographed animals from a close vantage point. While editing my film, I looked for emotive facial expressions and body language. In Photoshop, I brightened the eyes of my subjects to tease out as much detail as possible. I print my images on smooth paper with matte inks to lend them a velvety feel. The slight brown tone in these photographs was the result of extensive testing to find a shade that was lush without being cloying. I exhibit this work with prints sized at only 9 by 9 inches to encourage viewers to approach them. These creative choices reflect a tension between coolness and tenderness in my photography that is explored by curator Anne Wilkes Tucker in her essay for this book.

v

While I had been using portraiture techniques from the get-go, my earliest pictures were not truly portraits. From my journal at the time: "These images are self-portraits, or at the very least, they are manifestations of my hopes and fears

about what I will be like when I am old." Both my maternal grandmother and my mom developed Alzheimer's disease, leaving me to wonder whether I will die in that cruel manner. Whenever I lose my keys or forget a person's name, I feel a chill. *Is this the beginning of the end?* I began photographing old animals to confront this fear of aging in the hope of becoming inured to it. Although I trained my lens on animals, my initial pictures were not about them.

Meeting rescued farm animals and hearing their stories transformed me. I became a passionate advocate for these animals, and I wanted my images to speak on their behalf. It seemed selfish to photograph rescued animals for any other reason.[23] From that point on, I approached these images as portraits in earnest, and I endeavored to reveal something unique about each animal I photographed.

To that end, I adopted a practice of clearing my mind before I met with an animal. It helped me remain calm during our time together. Still, memories of my mother sometimes surfaced while I was working. One of the animals I met for this project was a blind turkey named Gandalf who lived at Pasado's Safe Haven in Sultan, Washington. Because he was blind, his eyes often had a blank quality to them. It was an unseasonably muggy day when I first met him, and Gandalf—like most turkeys—cooled down by breathing with his beak open. His empty gaze coupled with his gaping mouth transported me to my mother's bedside during her final months, when she was catatonic. I fled Gandalf's enclosure in tears after spending mere moments with him. It took a few more visits before I was finally able to see Gandalf and not my mother when I gazed at him through my viewfinder. I was struck by the bird's gentle and dignified nature, and I focused on these attributes while photographing him (plate 42).

After my approach to this project changed, I drew inspiration from Richard Avedon's unsettling portrait of Marilyn Monroe.[24] Avedon had spent an evening photographing the actress as she danced and flirted with the camera. After their session had wrapped, he observed her sitting quietly in the corner of his studio, her face devoid of expression. He grabbed his camera and with her tacit consent he recorded this rare unguarded moment. The resulting image shows Monroe looking spent and resigned: the dullness in her eyes, a jarring contrast to the shiny sequins on her dress. Although there is some debate regarding whether this portrait reveals the "real" Marilyn, the image shows a side of the actress that the public had never seen before.[25] It is one of my favorite Avedon images because it challenges viewers to question everything they think they know about Monroe.

I want the images in this book to accomplish the same thing for farm animals. With these intimate portraits, I aim to dispel the stereotype that farm animals are dumb beasts. The animals who appear in this book are sentient beings who think and feel and have unique personalities.[26] I am not claiming that they are like the anthropomorphic barnyard characters in *Charlotte's Web*. But they do experience pleasure and pain, joy and sorrow, fear and anger. They love their babies and experience great distress when they are separated from them. Some are shy and reserved; others, outgoing and affectionate. Some are loners; others develop close friendships with other animals. When these friends die, they mourn. We cannot know if animals experience emotions exactly the way we do, but that's beside the point. In *Personalities on the Plate*, biological anthropologist Barbara J. King writes, "No animal need be sentient *like us* to be sentient, just as no animal need be smart like us to be smart or feel emotions like ours to be known as a feeling being with a distinct and sometimes vivid personality."[27]

After a few sanctuary visits, I could no longer see a difference between the farm animals I met and the dogs and cats I have known. I included in this book a handful of portraits of elderly dogs to exemplify this point and to raise questions about why we pamper some animals and slaughter others.[28] At Indraloka Farm Sanctuary in Mehoopany, Pennsylvania, a pig named Jeremiah jumped with excitement when he saw Indra Lahiri, who nursed him back to health after he arrived there with severe pneumonia. Melvin (plate 13), an Angora goat who lived at Farm Sanctuary in Orland, California, put his front hooves up on his fence when sanctuary staff approached his enclosure. He gave visitors gentle head butts that reminded me of the friendly greetings my cats give me. I have met turkeys and chickens who enjoy being petted and even sit in people's laps. Each time I witnessed these exchanges of affection, I marveled at these animals. They had every reason to fear human beings, yet they had come to trust, and even love, their caregivers. Their bodies may have borne the scars of earlier abuse, but their spirits clearly did not.

VII

Most of the animals who appear in this book passed away within six months to a year after I had met them. On a few occasions, an animal died the day after I photographed her. These deaths are not surprising given the nature of this project, but they have been painful nonetheless. Since I began this project, both my parents

have passed away, two beloved cats succumbed to cancer, and a dear friend died after a terrible fall. Grief initially inspired this work, and it has been my constant companion as I have worked on this book.

Photography is a medium well-suited to explorations of mortality. Susan Sontag wrote in *On Photography*, "All photographs are *memento mori*. To take a photograph is to participate in another person's (or thing's) mortality, vulnerability, mutability. Precisely by slicing out this moment and freezing it, all photographs testify to time's relentless melt."[29] In his book *Camera Lucida*, French philosopher Roland Barthes likewise wrote, "Whether or not the subject is already dead, every photograph is this catastrophe. . . . There is always a defeat of Time in them: *that* is dead and *that* is going to die."[30]

These portraits can be viewed in this context, but I prefer to think of them as testaments to survival and endurance. To say that the animals in this book are the lucky ones is a massive understatement. Roughly fifty billion land animals are factory farmed globally each year.[31] It is nothing short of a miracle to be in the presence of a farm animal who has managed to reach old age. Most of their kin die before they are six months old. I hope the images in this book invite reflection upon what is lost when these animals are butchered in their youth.

Spending time with elderly farm animals has reminded me that old age is a luxury, not a curse. I will never stop being afraid of what the future has in store for me. But I want to face my eventual decline with the same stoicism and grace that the animals in these photographs have shown.

# Sanctuaries Visited

**Catskill Animal Sanctuary**
316 Old Stage Road
Saugerties, NY 12477
(845) 336-8447
https://casanctuary.org

**Equine Advocates**
PO Box 354
Chatham, NY 12037
(518) 245-1599
http://www.equineadvocates.org

**Farm Sanctuary Northern California Shelter**
19080 Newville Road
Corning, CA 96021
(530) 865-4617
http://www.farmsanctuary.org/the-sanctuaries/orland-ca/
(This location closed in 2018.)

**Farm Sanctuary New York Shelter**
3100 Aikens Road
Watkins Glen, NY 14891
(607) 583-2225, ext. 221
http://www.farmsanctuary.org/the-sanctuaries/watkins-glen-ny/

**Friends for Life**
Don Sanders Adoption Center
107 East 22nd Street
Houston, Texas 77008
(713) 863-9835
http://www.adoptfriends4life.org

**Harvest Home Animal Sanctuary**
PO Box 998
French Camp, CA 95231
(209) 244-7174
http://harvesthomesanctuary.org

**Indraloka Animal Sanctuary**
PO Box 155
Mehoopany, PA 18629
(570) 763-2908
http://www.indraloka.org

**Kindred Spirits**
12606 US Highway 27
Ocala, FL 34882
(877) 3-KINDRED
http://www.kssfl.org

**Pasado Safe Haven**
PO Box 171
Sultan, WA 98294
(360) 793-9393
http://www.pasadosafehaven.org

**Wildlife Rescue & Rehabilitation**
PO Box 369
Kendalia, TX 78027
(830) 336-2725
http://www.wildlife-rescue.org

**Winslow Farm Animal Sanctuary**
37 Eddy Street
Norton, MA 02766
(508) 285-6451
http://www.winslowfarm.com

**Woodstock Farm Animal Sanctuary**
2 Rescue Road
High Falls, NY 12440
(845) 247-5700
http://woodstocksanctuary.org

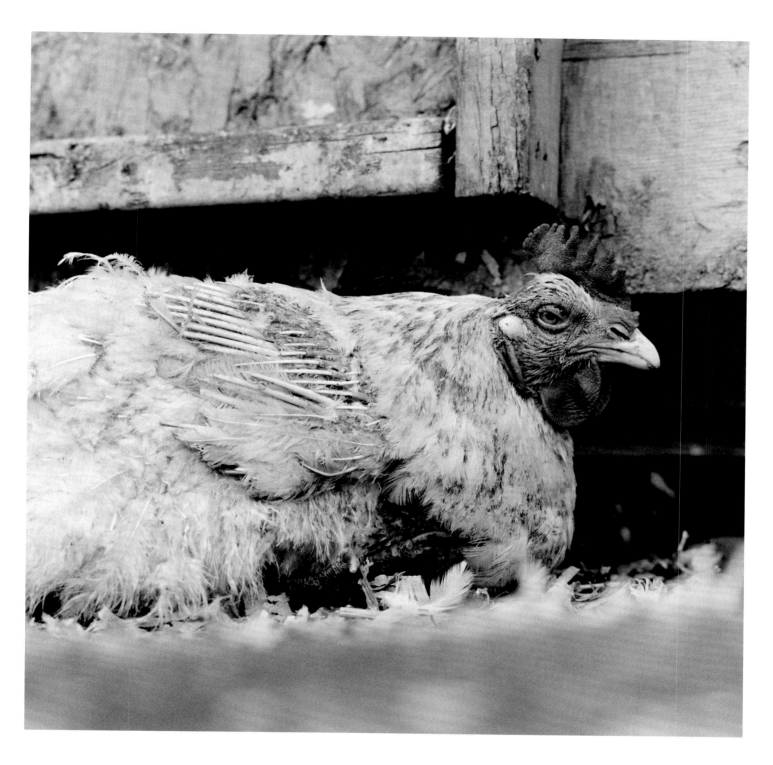

PLATE 1. This rooster, age unknown, was a factory farm survivor.

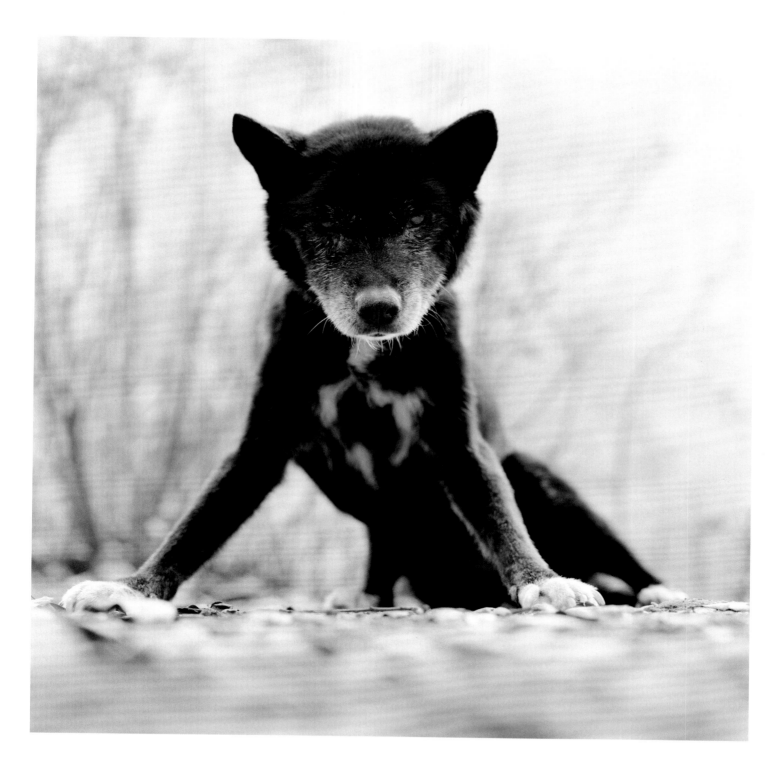

PLATE 2. Blue, an Australian Kelpie rescue dog, was a companion for 21 years.

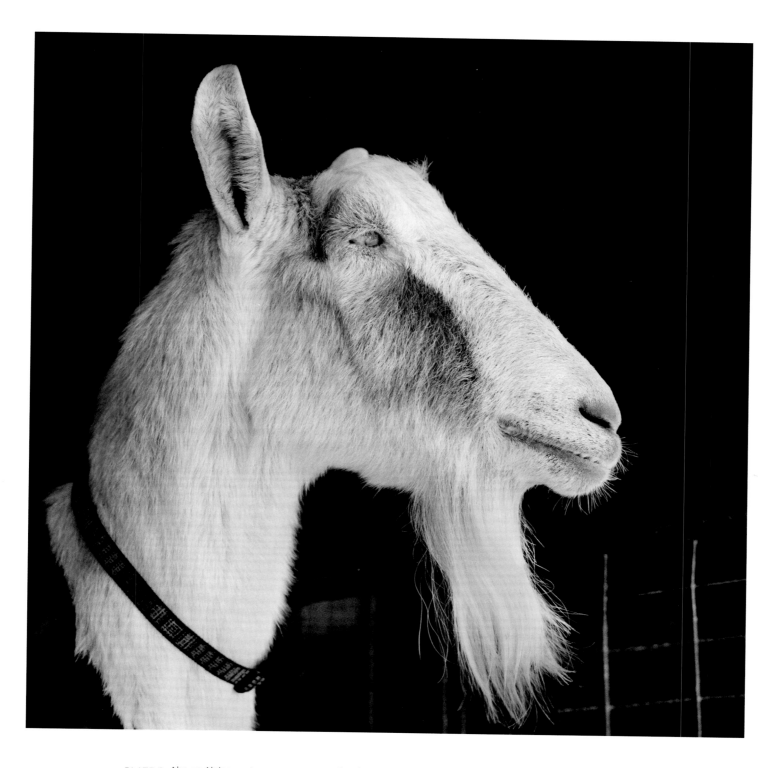

PLATE 3. Abe, an Alpine goat, age 21, was surrendered to a sanctuary after his guardian entered an assisted living facility.

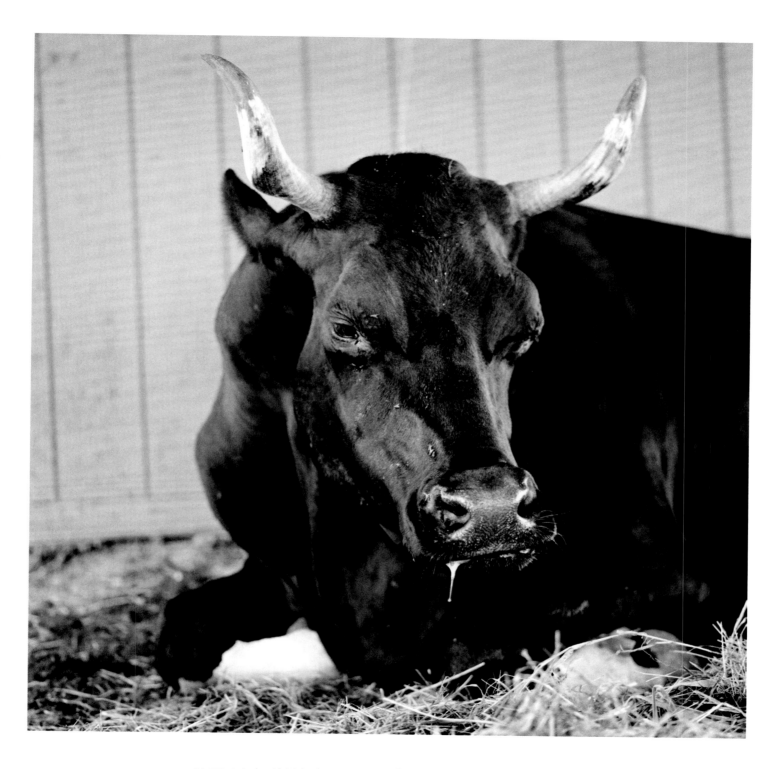

PLATE 4. Andy, a Holstein steer, age 14, was a former veal calf rescued from a dairy farm.

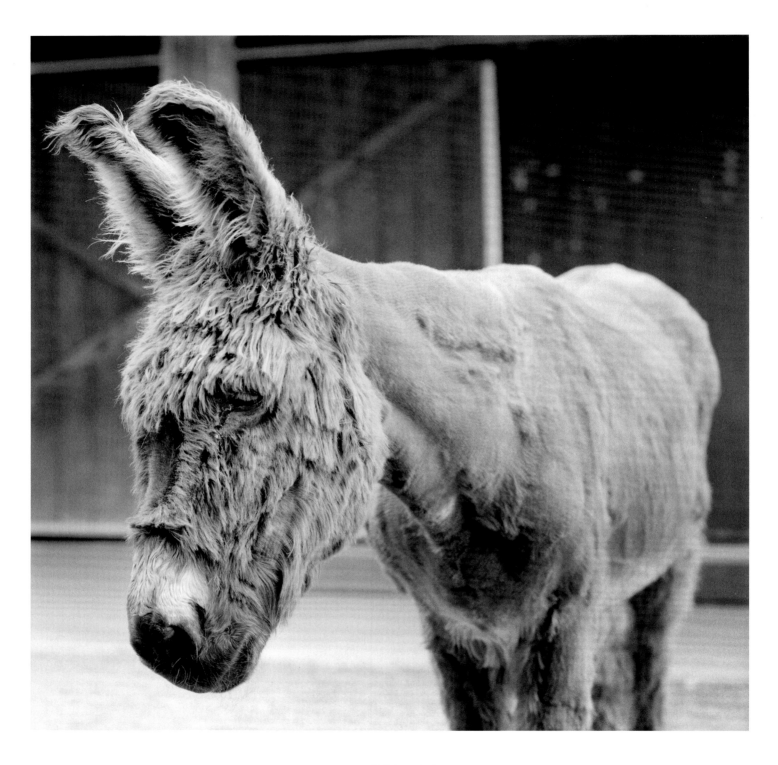

PLATES 5 AND 6. Babs, a donkey, age 24

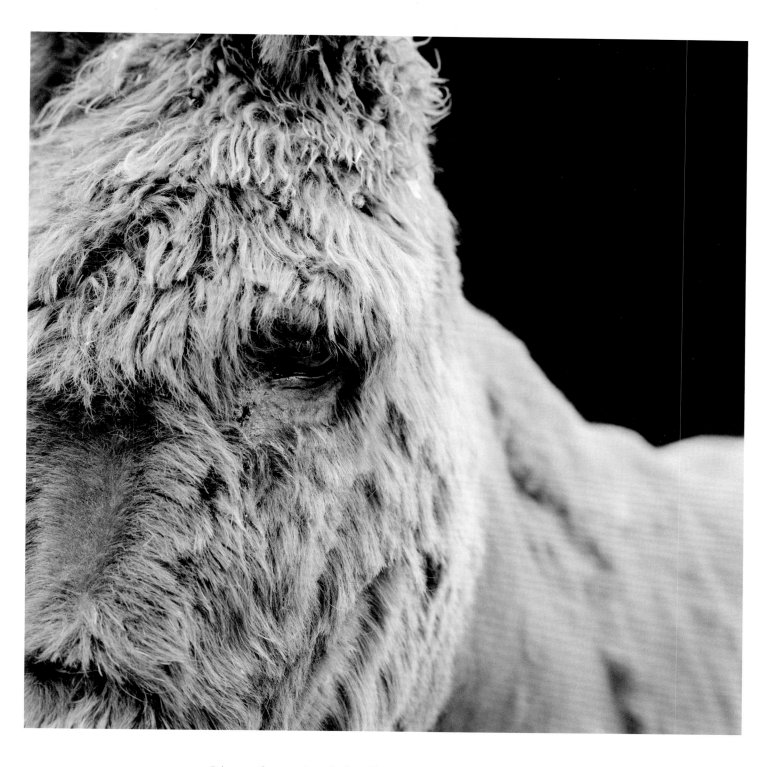

Babs was a former rodeo animal used for roping practice (see story on page 89).

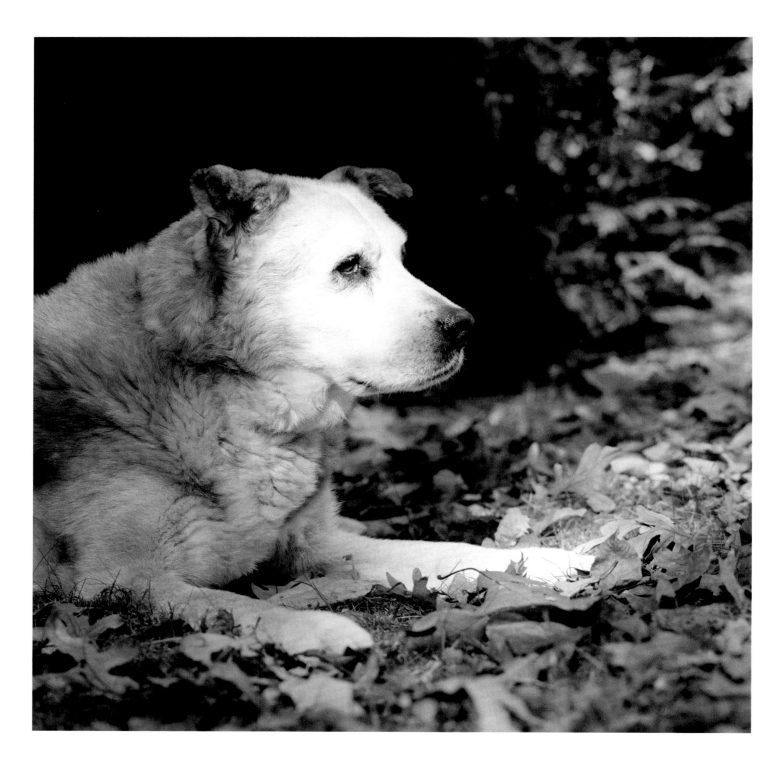

PLATES 7 AND 8. Bumper, a mixed breed dog, age 17

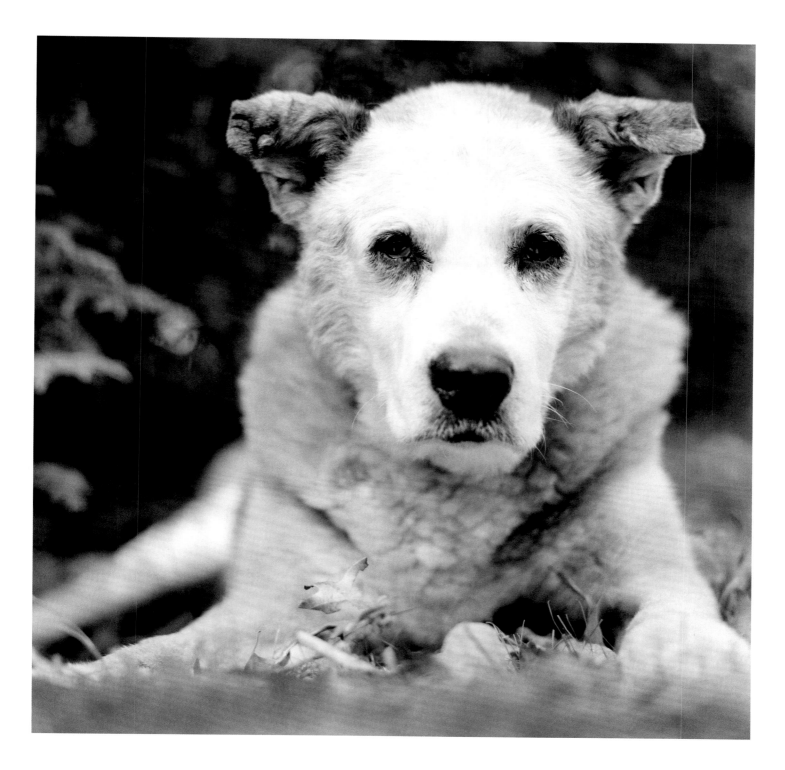

Bumper was adopted from a shelter.

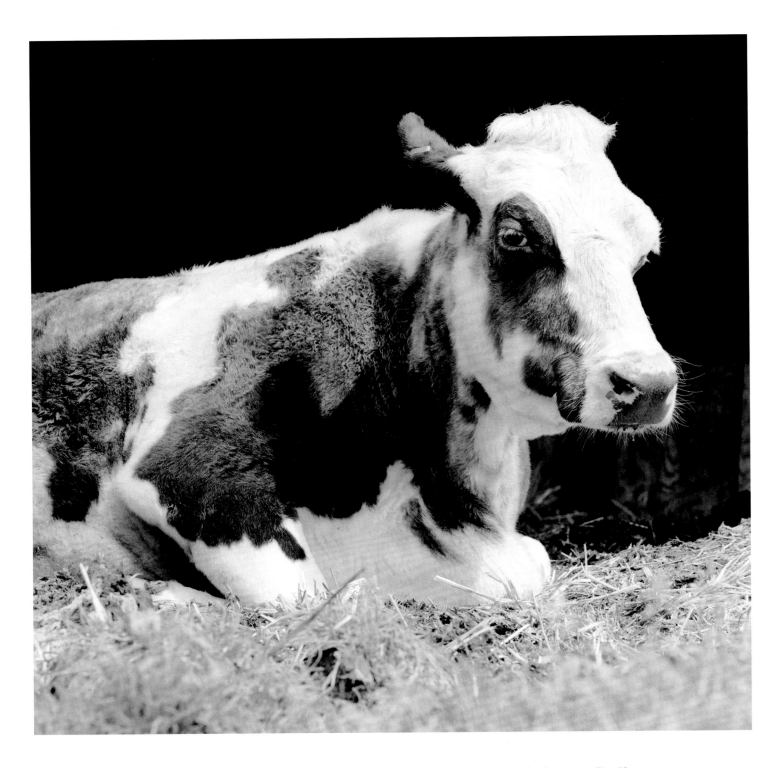

PLATE 9. Bessie, a Holstein cow, age 20, was repeatedly impregnated during the first four years of her life spent as a "milker" on a commercial dairy farm. Most retired dairy cows are slaughtered, and their flesh is rendered into hamburger meat or pet food. Bessie was rescued while en route to the slaughterhouse.

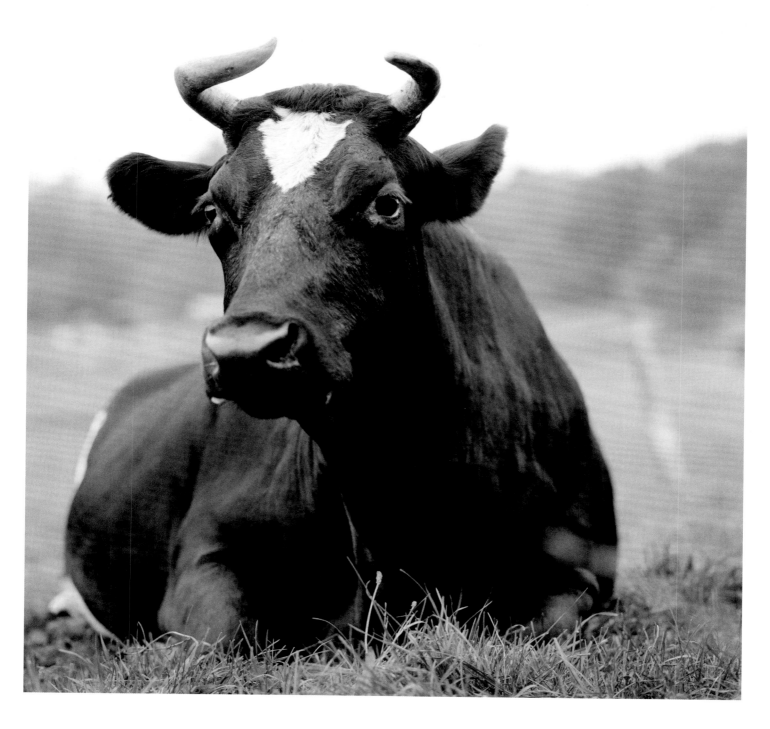

PLATE 10. Molly, a Holstein crossbreed, age 16, was rescued from a hoarder by animal control officers, who found her lying next to the decaying carcass of her mother.

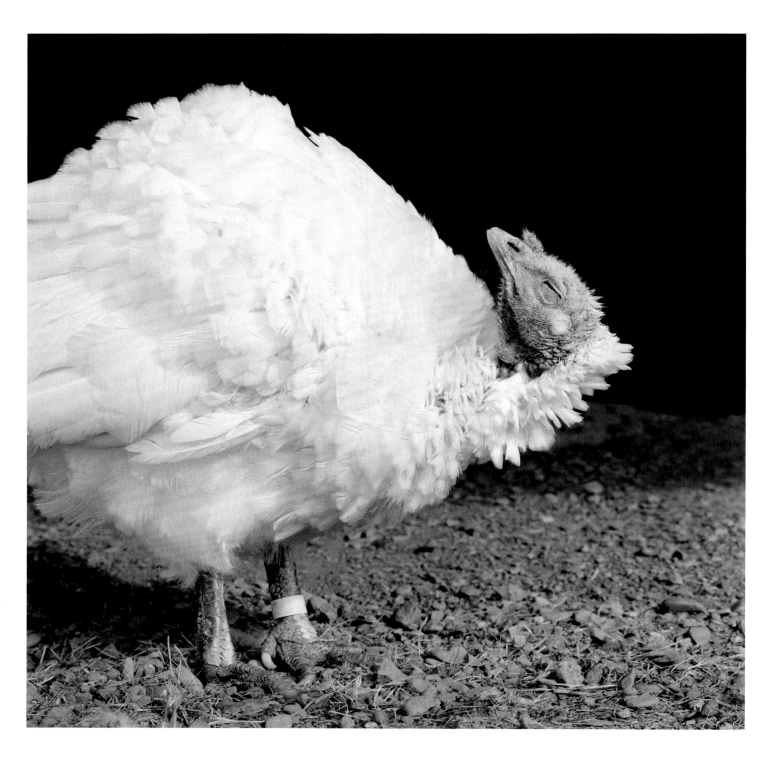

PLATES 11 AND 12. Ash, a Broad Breasted White turkey, age 8

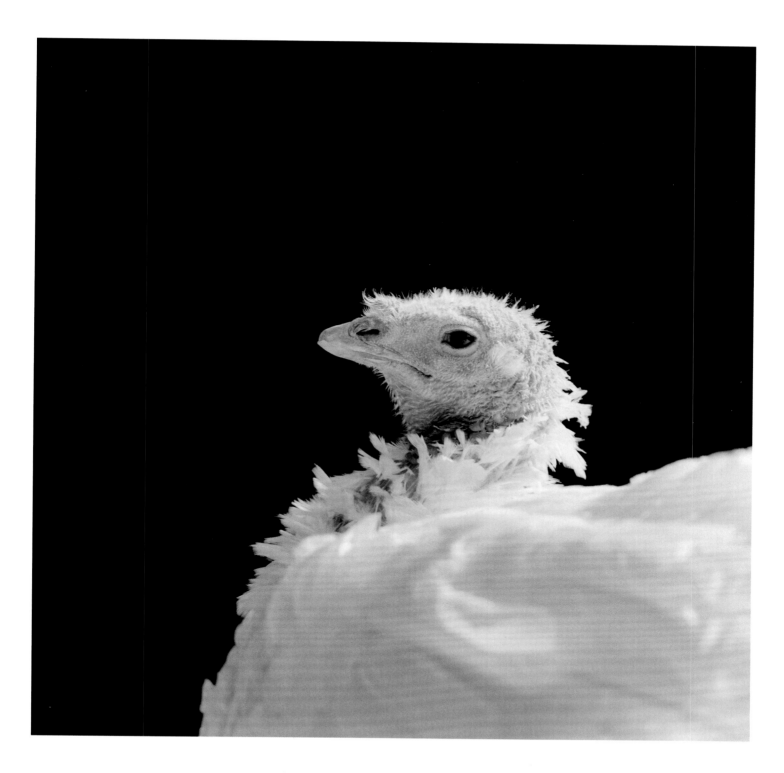

Ash was a factory farm survivor (see story on page 91).

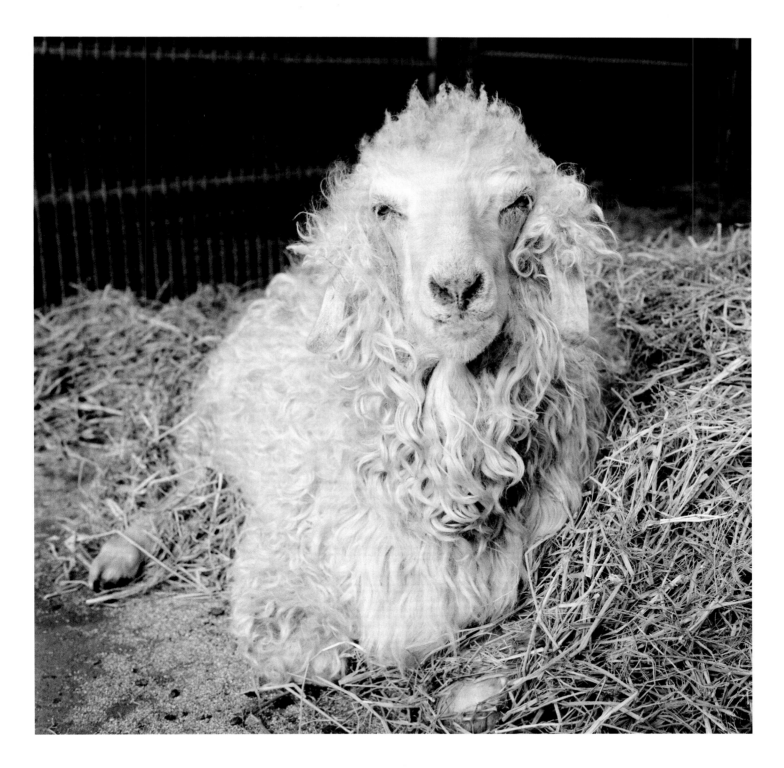

PLATE 13. Melvin, an Angora goat, age 11+, spent the first six years of his life tied to
a tire in a barren yard without shelter from the elements (see story on page 93).

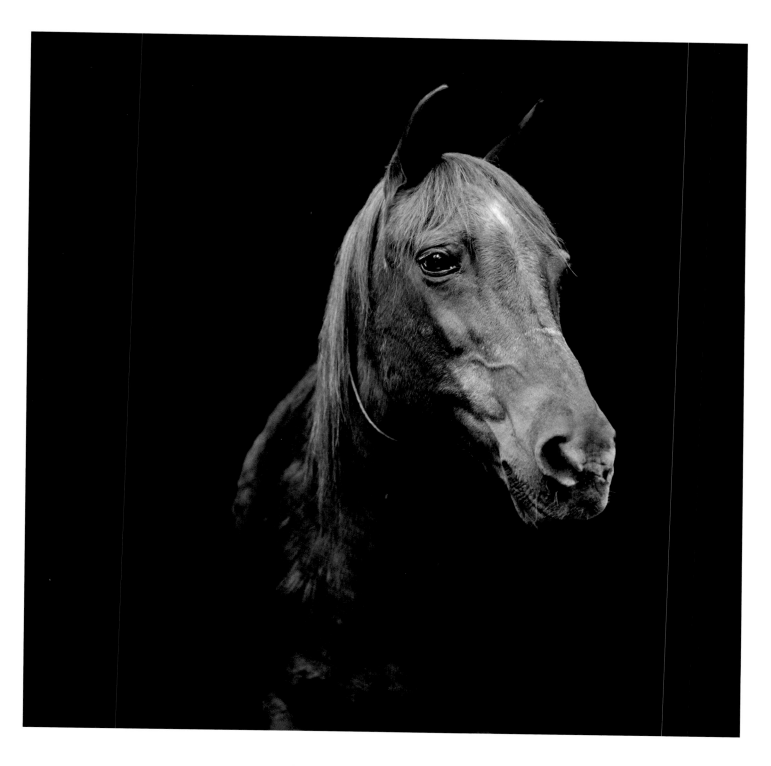

PLATE 14. Pumpkin, a Morgan/Arabian crossbreed, age 28, was surrendered
to a sanctuary after her guardian could no longer care for her.

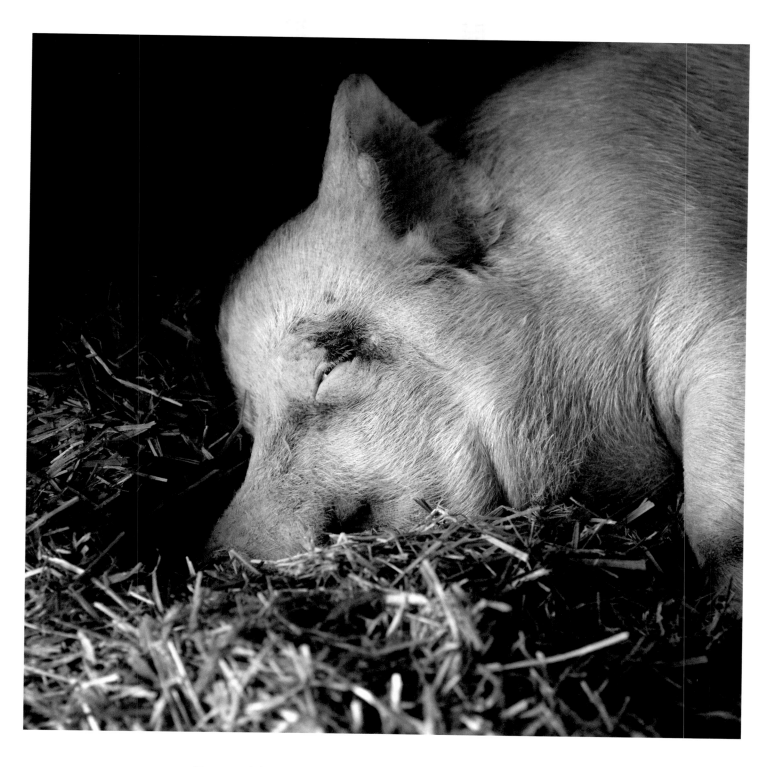

PLATE 15. Teresa, a Yorkshire pig, age 13, was rescued en route to the slaughterhouse (see story on page 94).

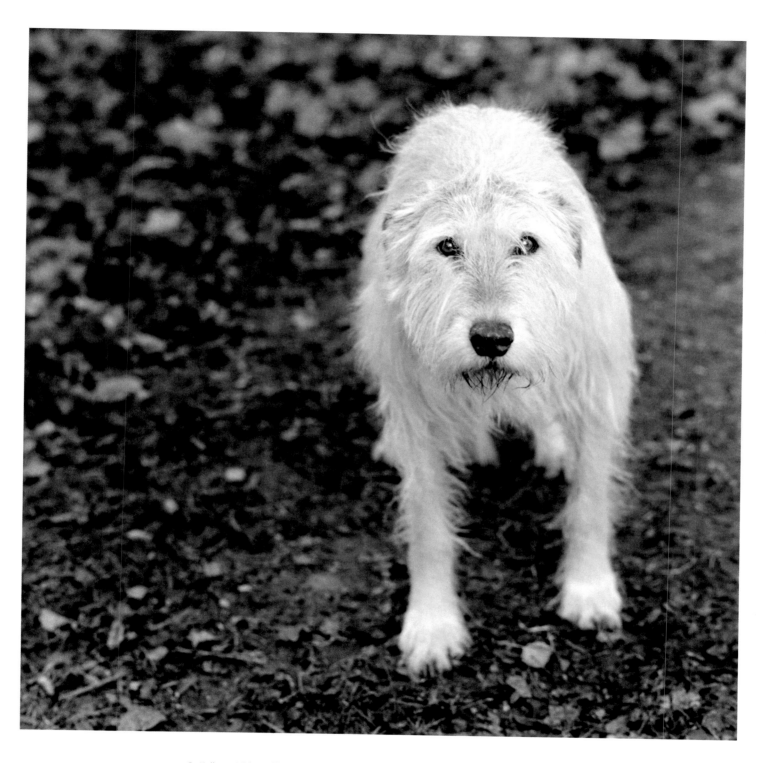

PLATE 16. Kelly, an Irish Wolfhound, age 11, was adopted from a breeder after giving birth to her final litter.

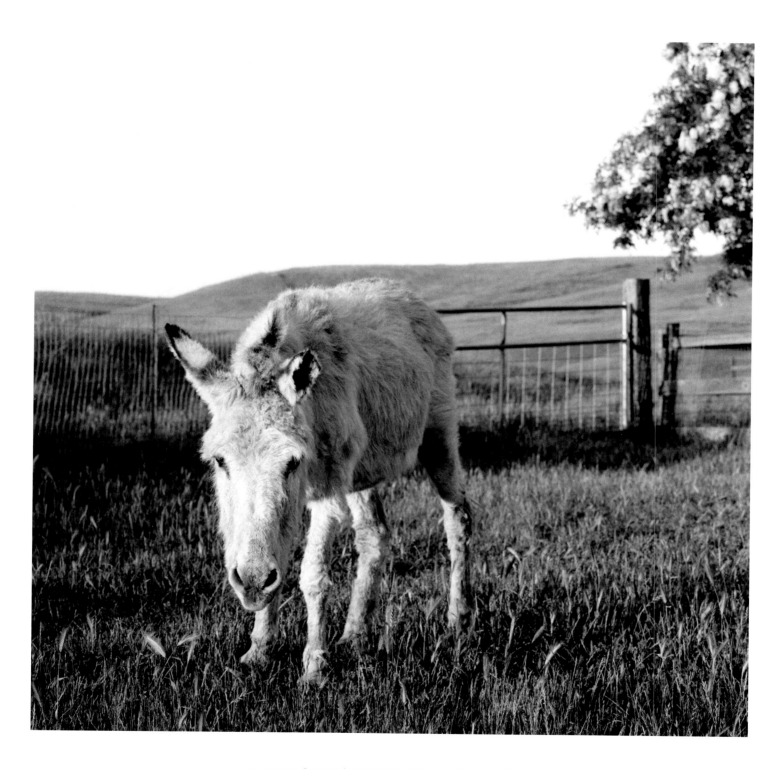

PLATE 17. Quartz, a burro, age 30, was rescued from slaughter.

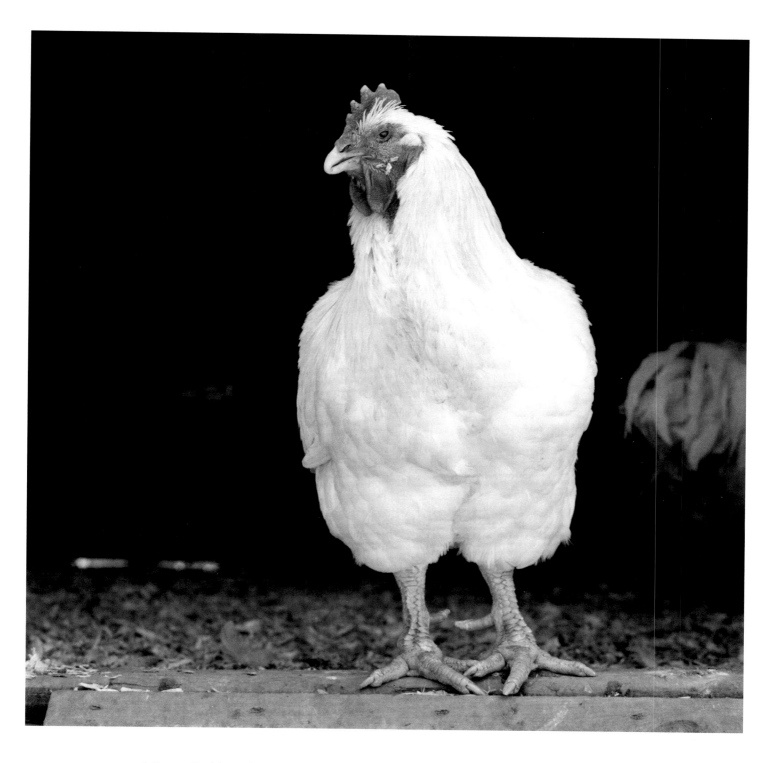

PLATE 18. Roger, a Cornish crossbreed, age 6, was rescued shortly before a Kaparot ceremony performed by ultra-Orthodox Jews to commemorate Yom Kippur. During the atonement ritual, a rooster is swung over each man's head to symbolically transfer his sins onto the animal. For women, a hen is used. The birds are then slaughtered at the end of the ritual.

PLATE 19. Valentino, a Holstein cow, age 19, was surrendered to a sanctuary, near death, after being born on a local commercial dairy farm (see story on page 96).

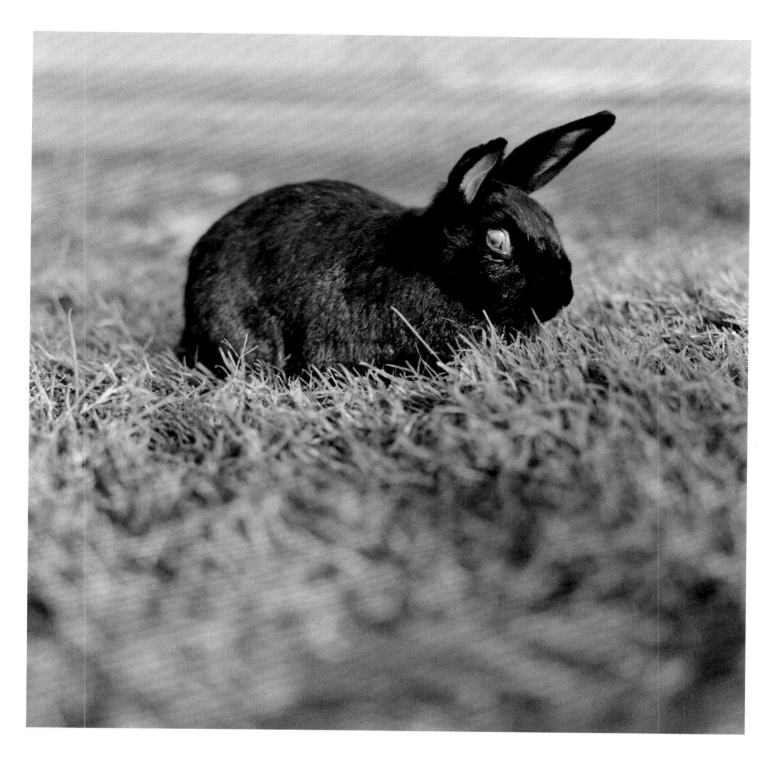

PLATE 20. Petey, a New Zealand rabbit, age 7, was surrendered to a sanctuary after his guardian passed away.

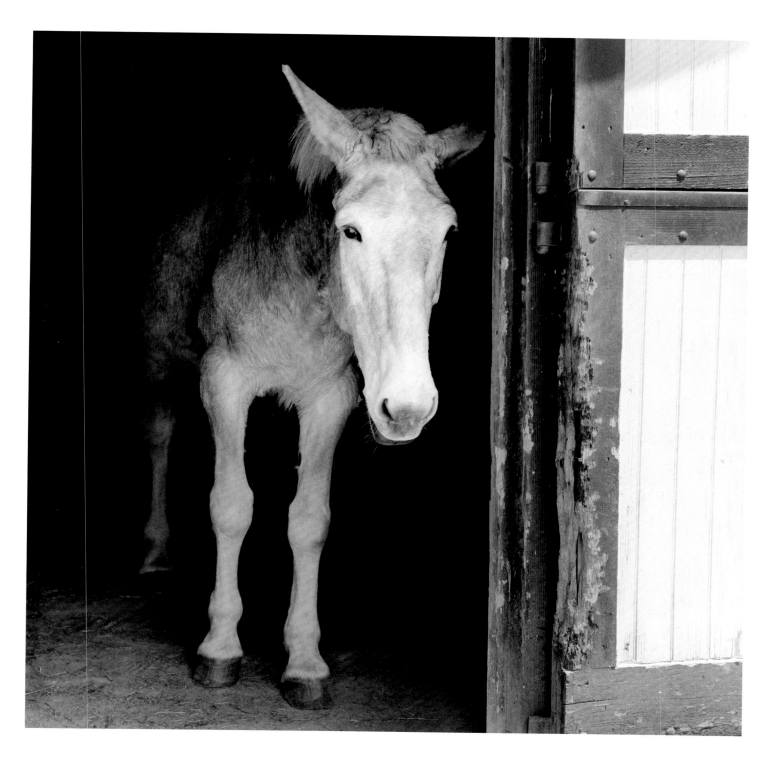

PLATE 21. Jewel, a mule, age 31, spent her youth pulling a plow on an Amish farm in Pennsylvania.
She was purchased at auction by the sanctuary where she lived for the remainder of her life.

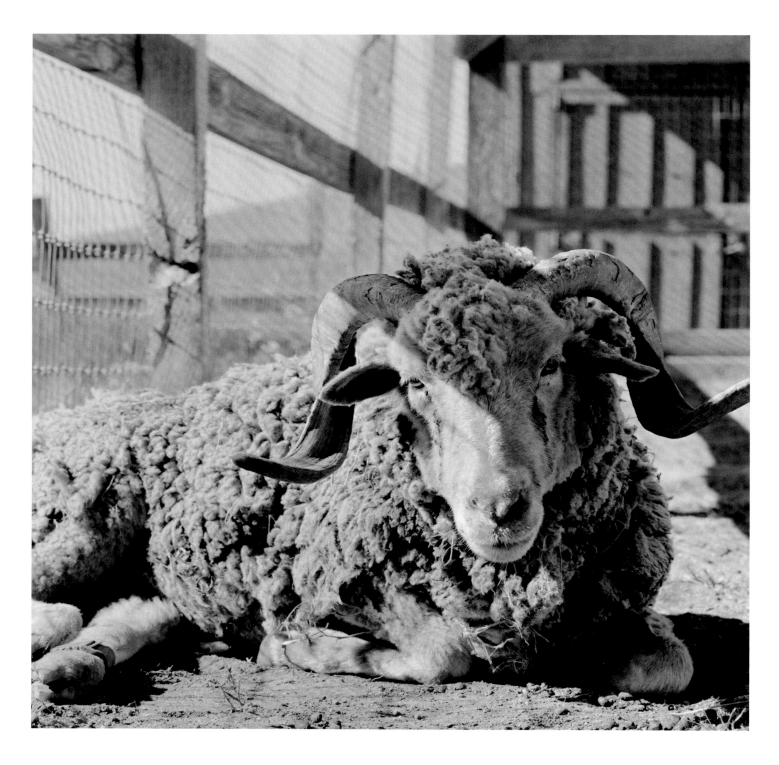

PLATE 22. Bogart, a sheep, age 16, roamed free with a herd on Santa Cruz Island off the coast of California. Bogart and his herd were rescued from planned extermination after the National Park Service deemed them a "nuisance."

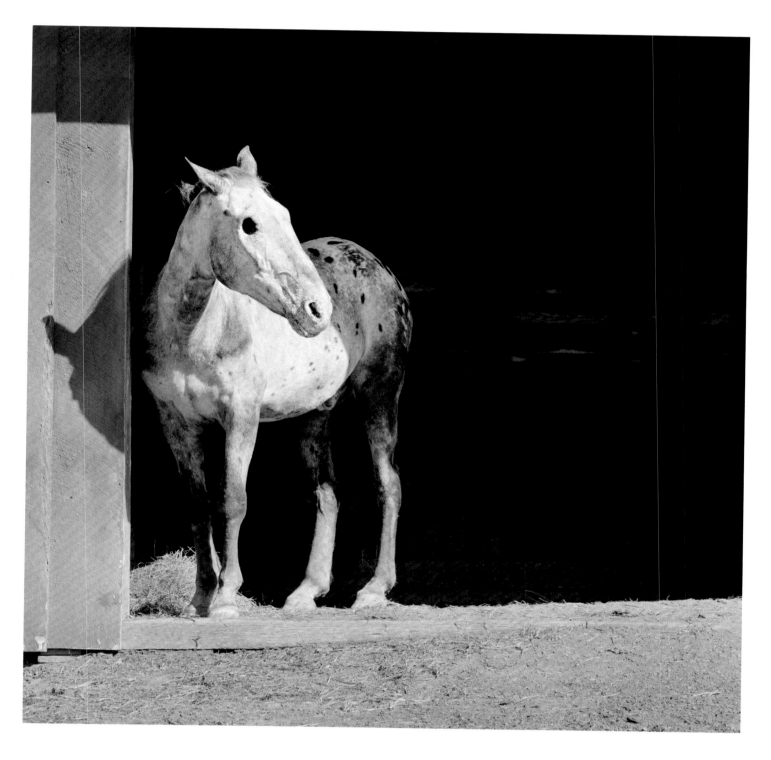

PLATE 23. Buddy, an Appaloosa horse, age 28, was surrendered to a sanctuary when his guardians could not properly
care for him after he lost his sight. He suffered from debilitating panic attacks, which took months of training to overcome. Buddy
suffered significantly from iritis. Because he was already blind, his eyes were removed to resolve this painful condition.

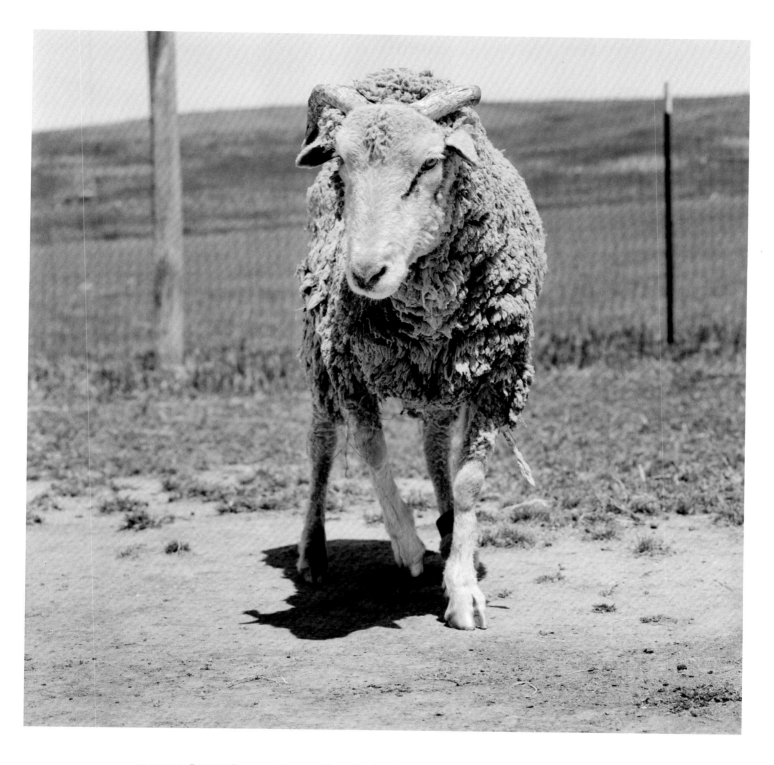

PLATE 24. Forest, a sheep, age 16, roamed free with a herd on Santa Cruz Island off the coast of California. Forest and his herd were rescued from planned extermination after the National Park Service deemed them a "nuisance."

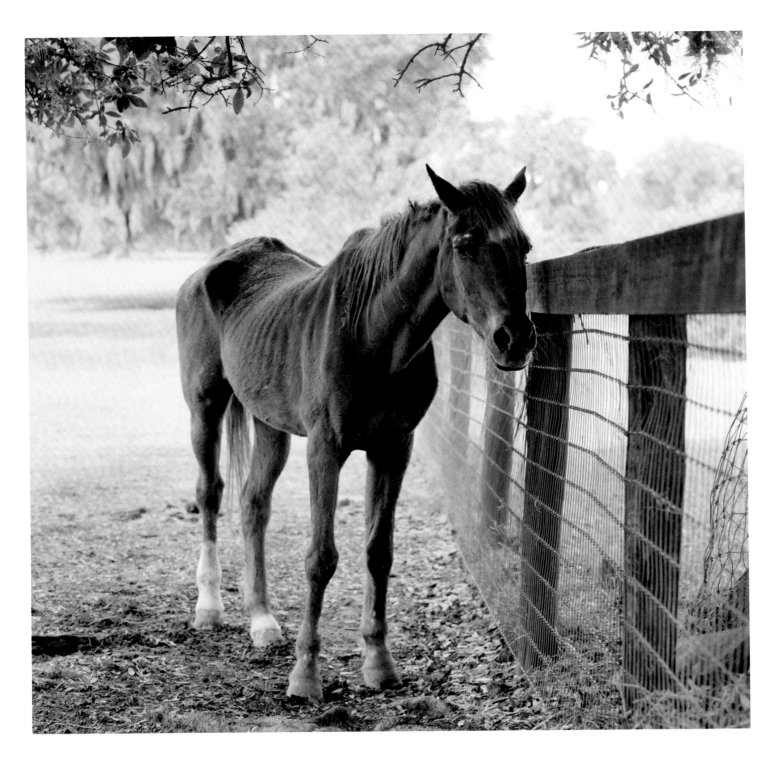

PLATES 25 AND 26. Star, an Arabian crossbreed, age 34

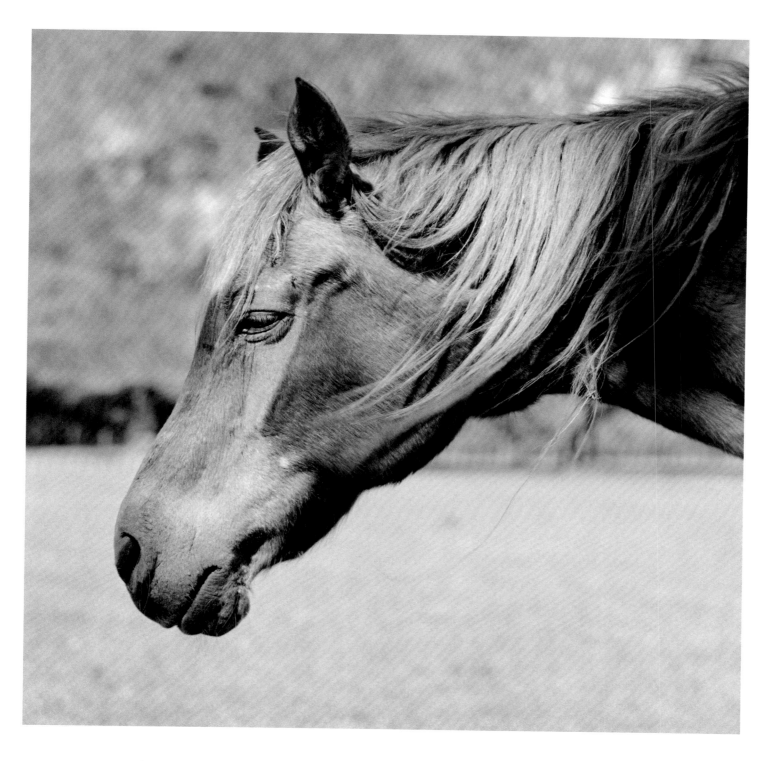

Star was purchased by a horse lover at an auction frequented by kill-buyers representing the overseas horsemeat trade. She was surrendered to a sanctuary when her guardian could no longer care for her.

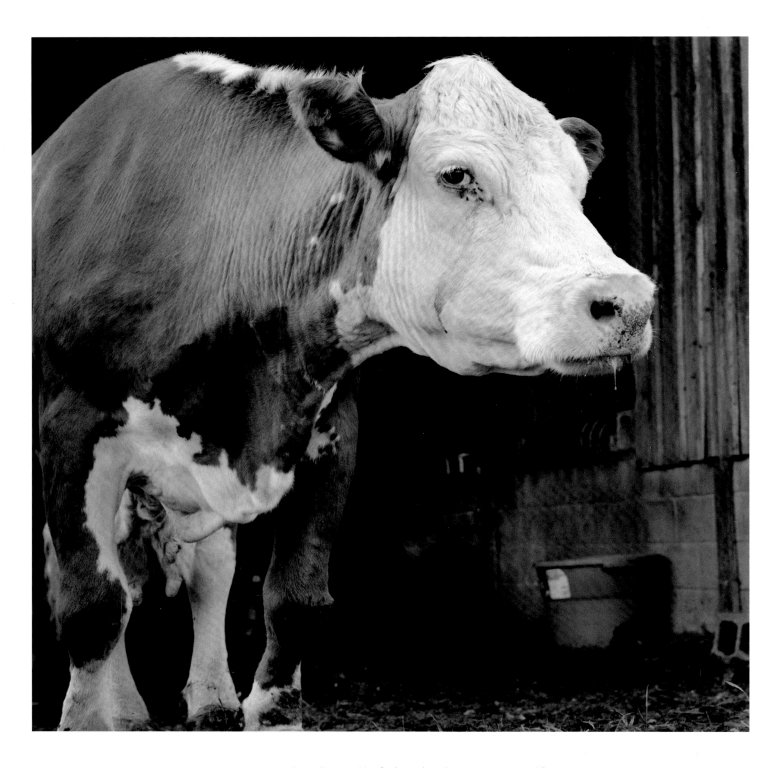

PLATE 27. Penny Power, a Hereford crossbreed, age 30, was rescued from
slaughter after spending her youth as a "breeder" on a beef farm.

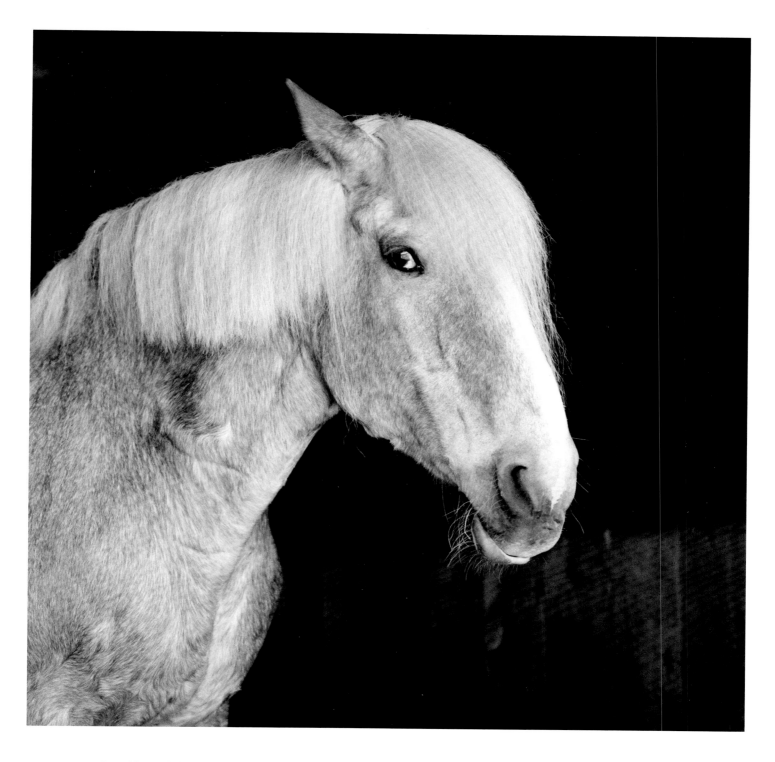

PLATE 28. Mariclare, a draft crossbreed, age 27+, was rescued from a factory farm in Canada that harvests pregnant mare urine (PMU) to produce hormone replacement drugs (e.g., Premarin, Prempro, Duavee). At PMU factories, mares are repeatedly impregnated and confined to narrow pens with urine collection harnesses strapped on them. They are kept dehydrated to ensure that their urine remains concentrated. As with the dairy industry, male offspring hold little financial value to PMU farmers. They are either slaughtered or sold at auction to the overseas horsemeat trade. Spent mares meet the same fate.

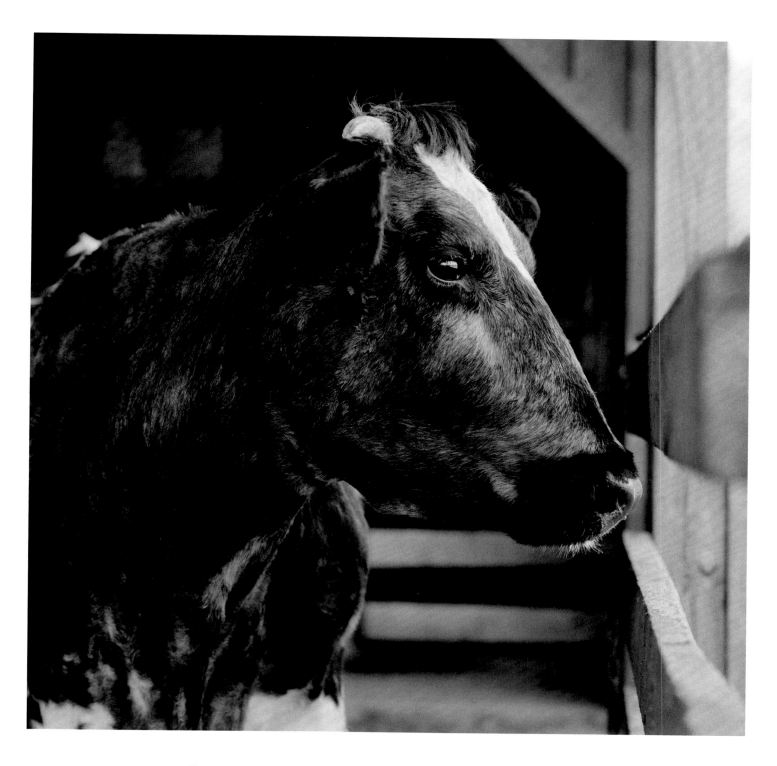

PLATE 29. Stella, a Holstein cow, age 18, lived for several years under strict confinement due to a surgically implanted cannula that led directly into her rumen (the first chamber of her stomach). Microbes from her rumen were routinely collected to treat sick cows, which is a practice known as transfaunation. Her fistula was removed prior to her surrender to a sanctuary.

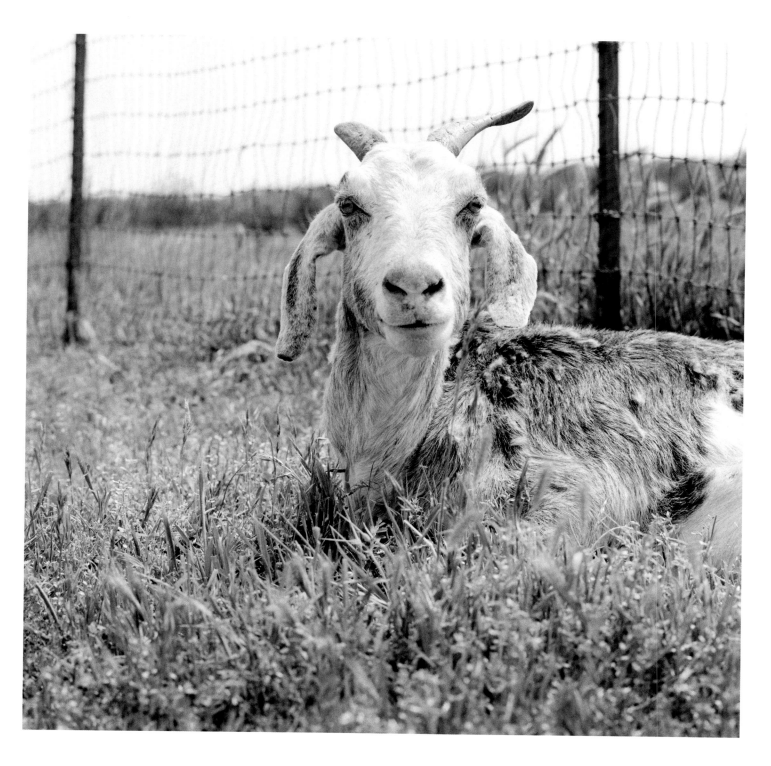

PLATE 30. Swoosie, a Nubian crossbreed, age 14+, endured severe neglect while residing at a feedlot-slaughterhouse facility.

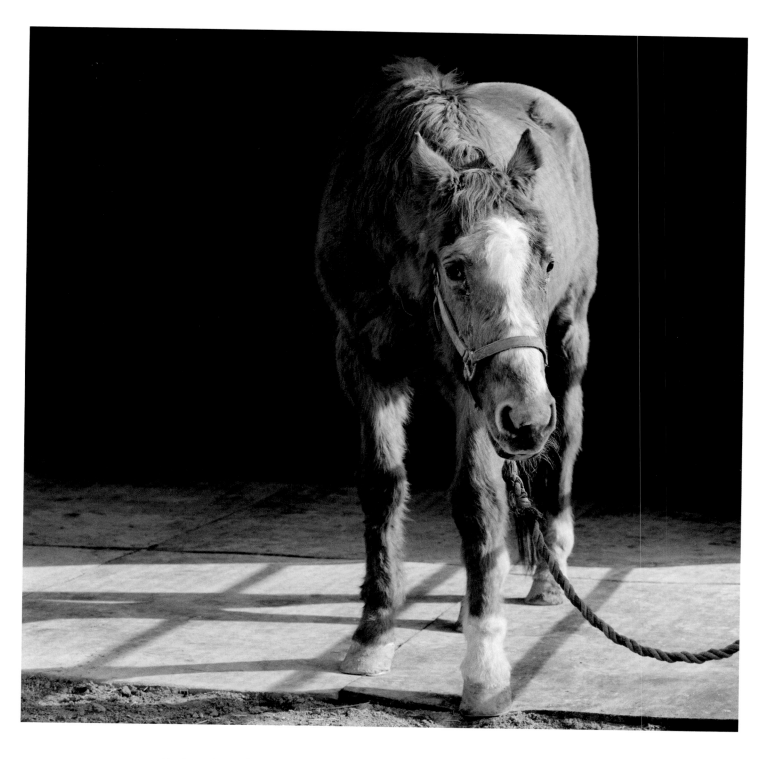

PLATE 31. Handsome One, a Thoroughbred horse, age 33, was surrendered to a sanctuary when he retired from racing.

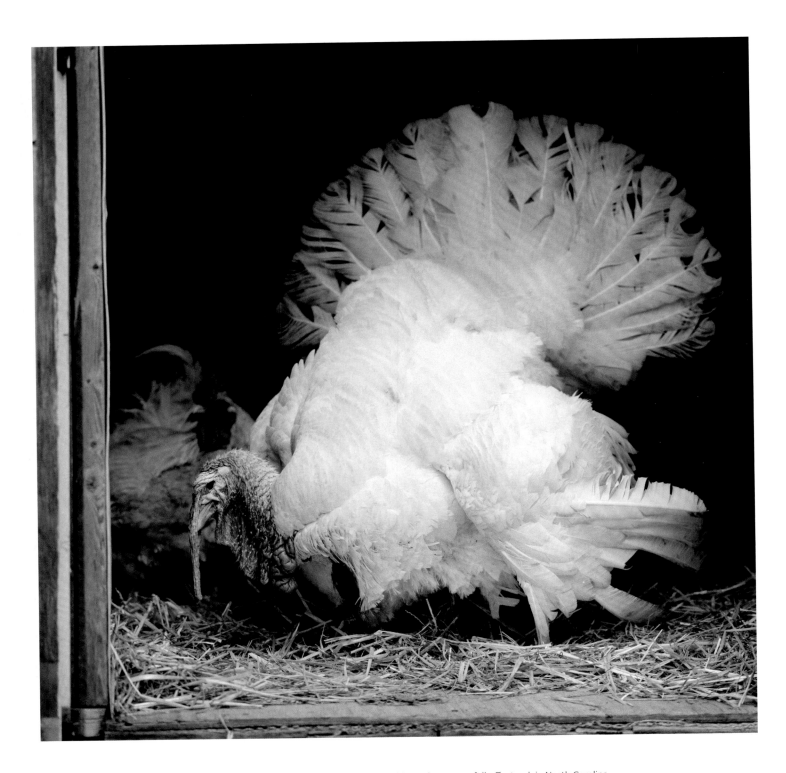

PLATES 32 AND 33. Tom, a Broad Breasted White turkey, age 7, fell off a truck in North Carolina.

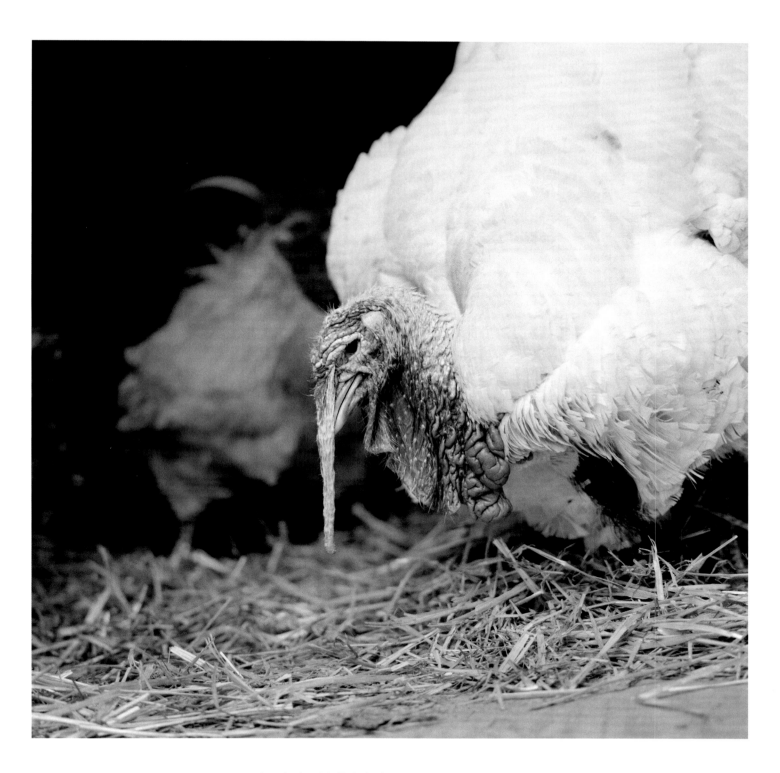

Because Tom was a young poult at the time, it is likely that he was being transported from a hatchery to a "finishing farm."

PLATES 34 AND 35. Violet, a potbellied pig, age 12

Born with her rear legs partially paralyzed, Violet was surrendered to a sanctuary because her guardian could not properly care for her special needs.

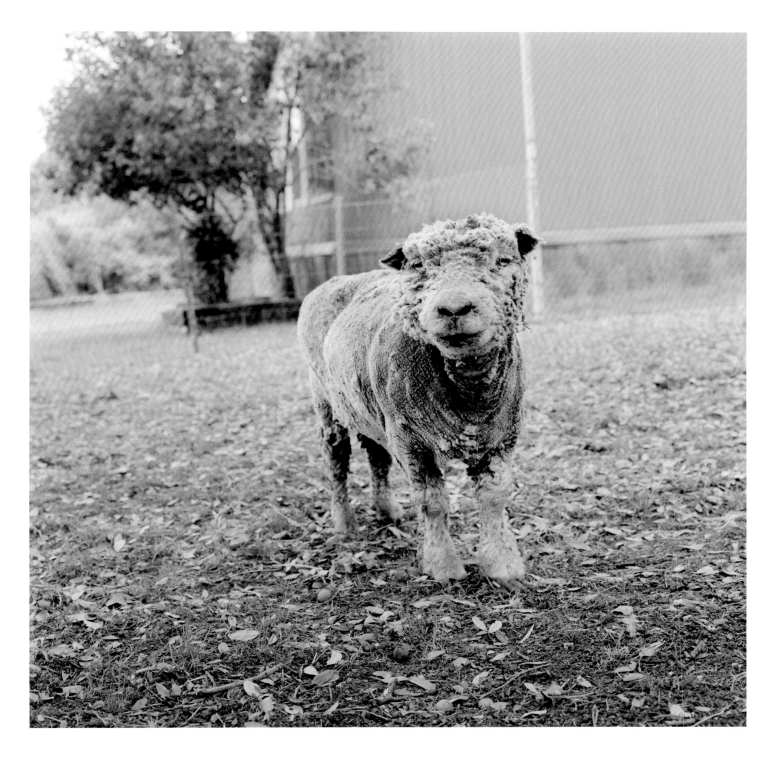

PLATE 36. Phyllis, a Southdown sheep, age 13, was farmed for wool for the first eight years of her life prior to being surrendered to a sanctuary.

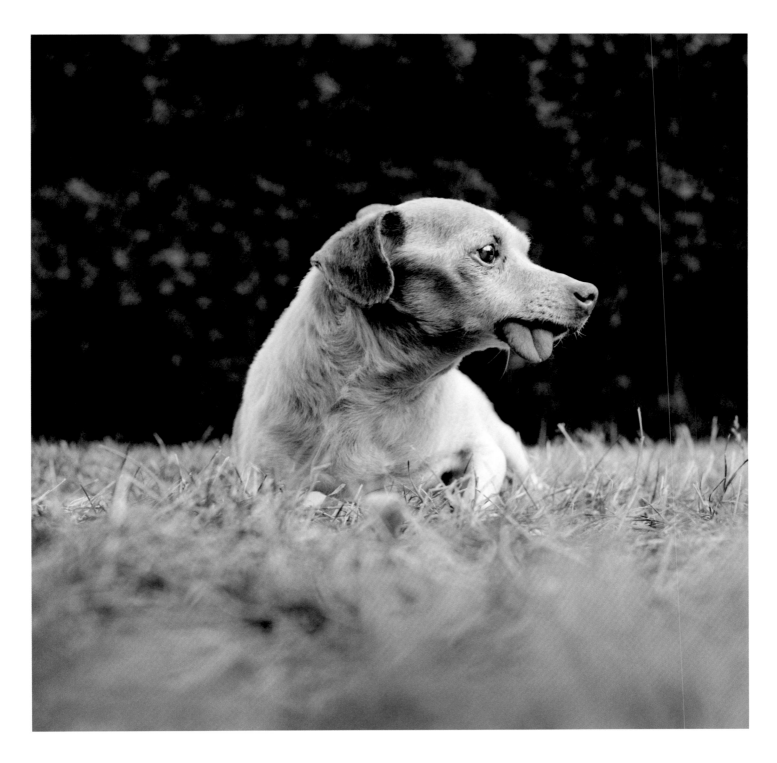

PLATE 37. Murphy, a Jack Russell Terrier, age 16+, was adopted as a senior dog from a high-kill shelter. He had untreated dental disease so severe that all his teeth needed to be extracted. The infection had spread to his jaw and caused his tongue to permanently hang out of his mouth.

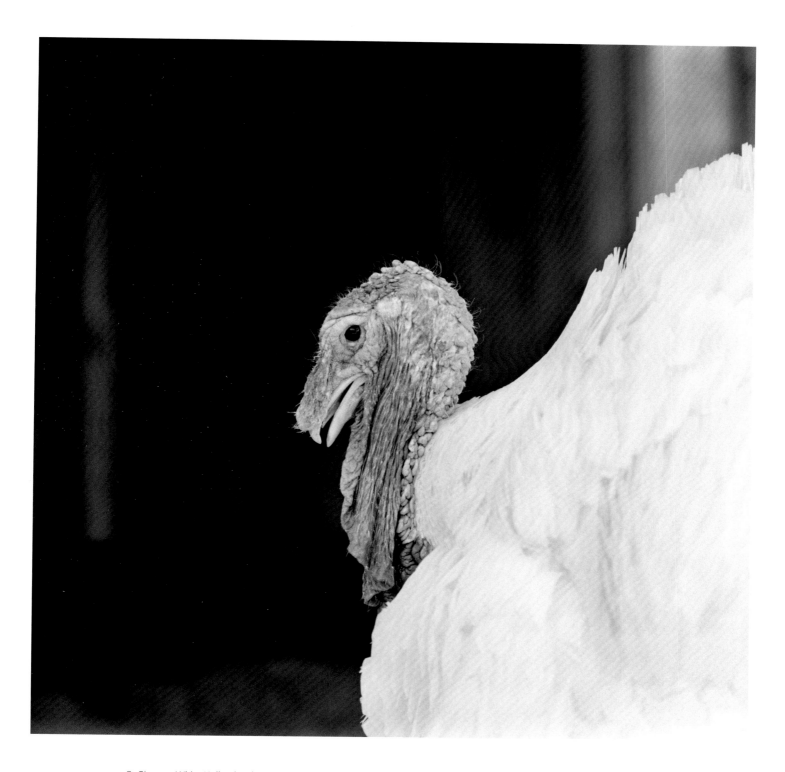

PLATE 38. Sierra, a White Holland turkey, age 3, was rescued as a young poult from a commercial hatchery that supplies turkeys to factory farms.

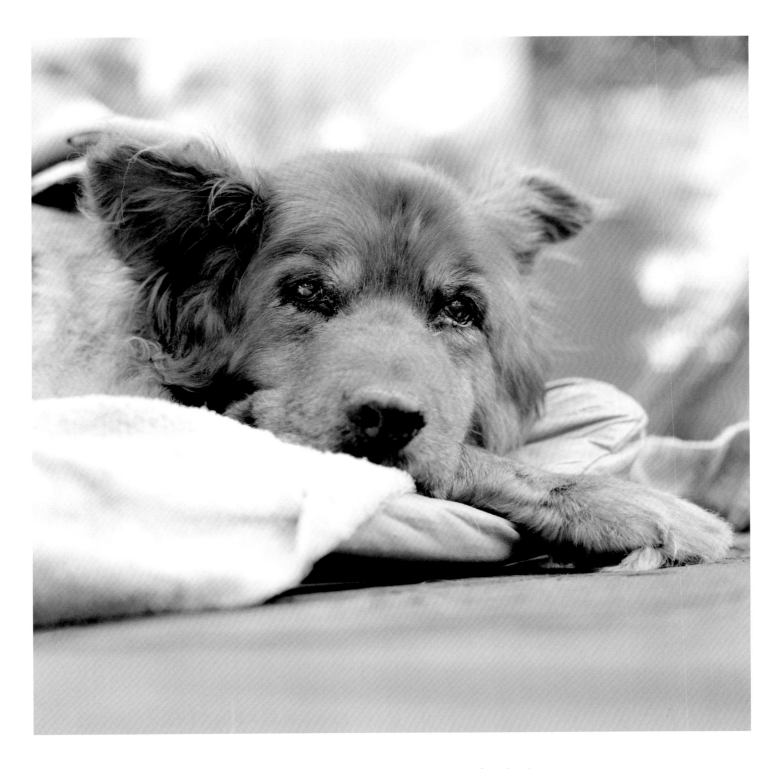

PLATE 39. Red, a mixed breed rescue dog, age 14+, in foster hospice care

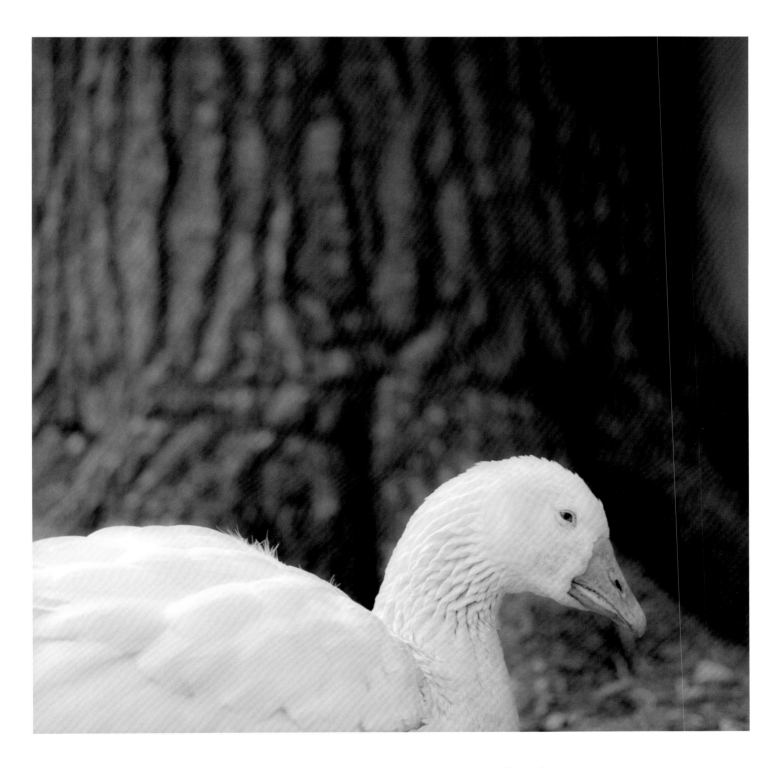

PLATE 40. Blue, an Embden goose, age 28, whose rescue details are unknown

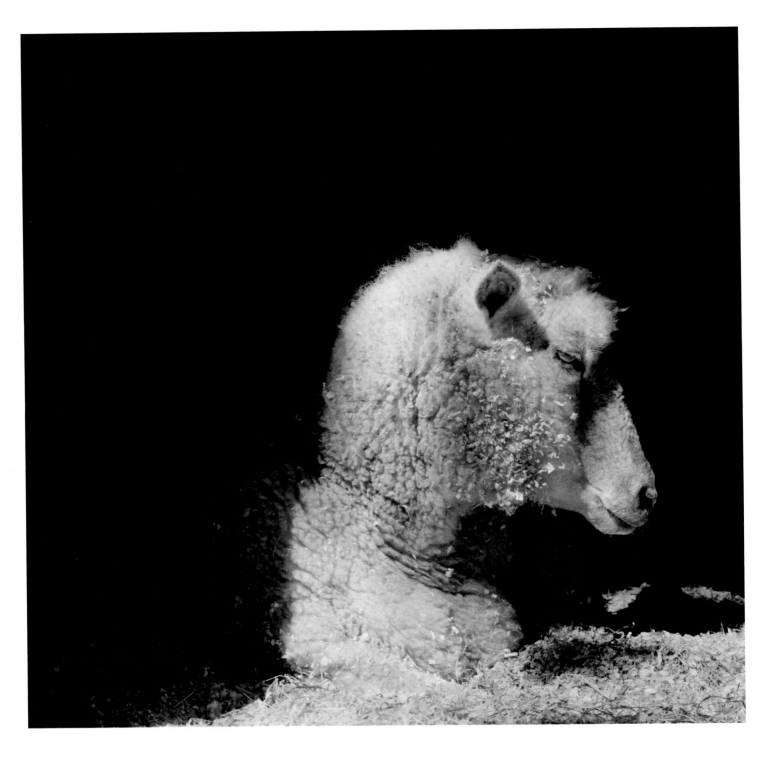

PLATE 41. Isaiah, a Finnsheep, age 12, was rescued with Zebulon (plate 45) as part of a cruelty investigation. They had been kept in a small cage for the first eight months of their lives. Both developed severe arthritis as a result of their early confinement.

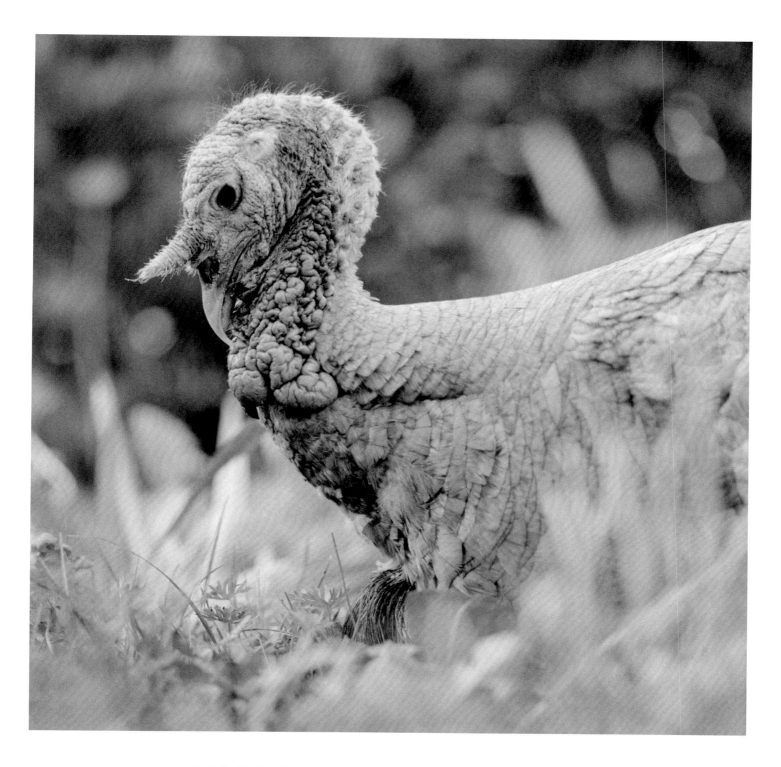

PLATE 42. Gandalf, a Blue Slate turkey, age 12, was found near death during a rescue operation on a hoarder's property.

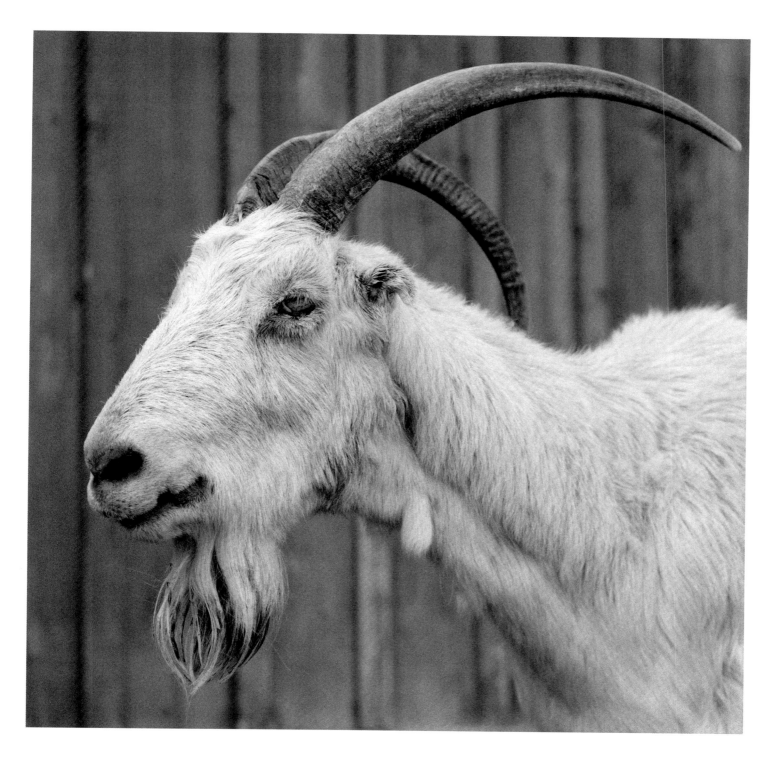

PLATE 43. Cecil, a LaMancha/Saanen crossbreed, age 14+, was rescued along with 100 other neglected animals from a poorly run sanctuary.

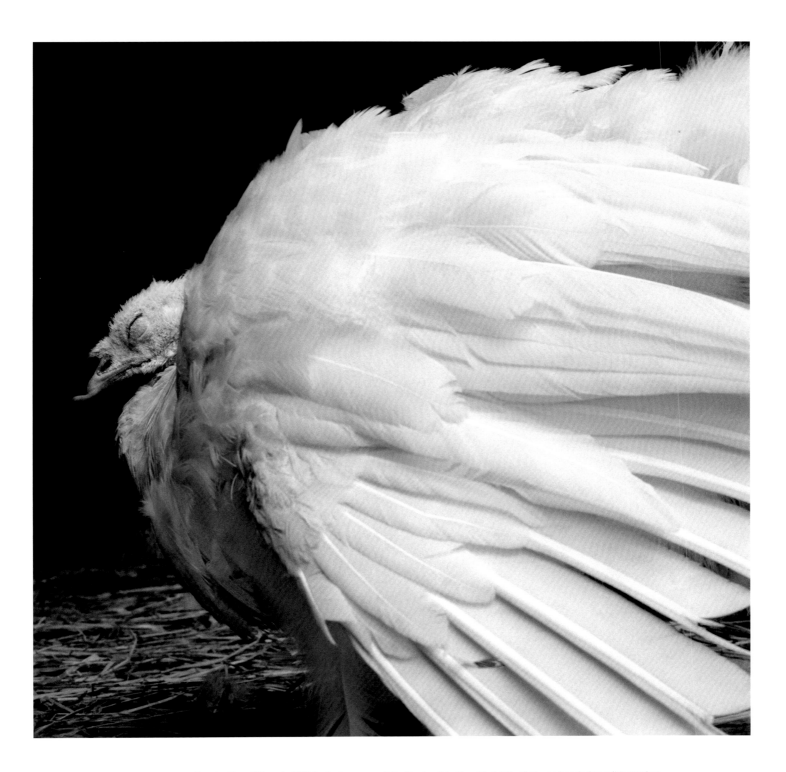

PLATE 44, Pearl, a Broad Breasted White turkey, age 7, fell off a truck in New York City that was headed to a live market.

PLATE 45. Zebulon, a Finnsheep, age 12, was rescued with Isaiah (plate 41) as part of a cruelty investigation. They had been kept in a small cage for the first eight months of their lives. Both developed severe arthritis as a result of their early confinement.

# Animal Stories

ISA LESHKO

Although I care about all the animals I photographed for this project, some affected me more profoundly than others. I share their stories here. These animals led remarkable lives, but they themselves were not remarkable for their species. As you read about them, please keep in mind what made Babs, Ash, Melvin, Teresa, and Valentino exceptional: it wasn't their memorable personalities or intelligence; it was that they escaped their abusive circumstances, unlike the billions of their kind who never will.

## BABS

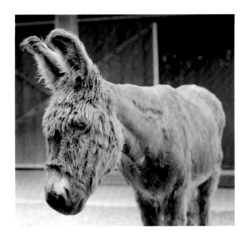

The moment I saw Babs's brown unruly fur, I thought of my favorite Sesame Street character from childhood, Mr. Snuffleupagus. Then I looked into her soulful eyes, and all comparisons to Snuffy abruptly halted. The old donkey's eyes had a weariness that suggested she had endured trauma at some point in her life.

During the first seventeen years of her life, Babs (plates 5 and 6) had been used for roping practice on a ranch in Eastern Washington. Donkeys are inexpensive, so cattle ranchers often learn roping techniques on them instead of on mechanical dummies. Many rodeos also use donkeys for entry-level roping competitions. Roping involves electrically shocking a donkey to make her run, chasing her on horseback, and then tossing a lasso around her neck or rear legs to pull her to the ground.[1] Donkeys endure this practice repeatedly until they are exhausted, maimed, or killed.

When Babs arrived at Pasado's Safe Haven in Sultan, Washington, she was covered in rope burns. She also suffered from Equine Cushing's disease, a pituitary disorder that causes insulin resistance and hyperglycemia. She was placed on a restricted diet of hay that had been soaked in water to reduce the sugar content. Whenever she was out of her stall, she had to wear a muzzle that prevented her from grazing on grass.

Babs also arrived at the sanctuary with chronic laminitis, a painful inflammation of tissues (laminae) in equine hooves that leads to lameness. Her condition was too severe to cure, but Pasado's animal care workers managed her pain with twice-daily ice baths, massage, and acupuncture. She also wore orthotic boots throughout the day.

Despite her history of abuse, Babs trusted her caregivers and tolerated the foot treatments. She was no pushover, though, and was never shy about expressing her displeasure. If her meals were even a few minutes late, she would bray loudly until the food came. She enjoyed massages but snapped at anyone who tried to brush her. She eventually relented and permitted the grooming, but immediately afterward, she would roll around in her stall's wood shavings in protest. She was perpetually covered with wood chips, and staff referred to them as her sparkles.

Babs was closest to a blind old Shetland pony named Peach Pie who had been rescued from a hoarder. Although Babs could be quite domineering with other animals at the sanctuary, she was gentle with Peach. Soon they spent all their waking hours together. Like any close companions, the two would occasionally quarrel. During these arguments, the pair's attempts at ferocity were quite comical. Babs would kick her hind legs up in the air, but because of her orthopedic issues, she could only lift her hooves off the ground by at most a foot. Peach would respond by half-heartedly biting at the air. After a few minutes of fighting, the two would consider the matter settled and resume enjoying each other's company.

Babs was younger than Peach, and when he died her caregivers tried to pair her with a goat named Ethel. Although Babs was receptive to the new friendship, the goat was terrified of her and ran away whenever she came near. Fortunately, a pair of young miniature donkeys named Jacques and Ole arrived at the sanctuary. Despite her age, Babs went into heat upon meeting the teenage boys, and sanctuary staff jokingly called her a cougar. Although the boys had been neutered and were considerably shorter than Babs, they still tried mounting her. They were separated from Babs until her heat period ended. When they were reintroduced, a platonic friendship blossomed. The trio often got into trouble, especially after they figured out how to open the gate to their pasture. Sanctuary staff did not mind their antics though because they were delighted to see Babs so happy. Later, as her health deteriorated, Jacques and Ole remained close by her, even when she required stall rest.

A year after I had photographed Babs, I returned to Pasado's Safe Haven on my final trip for this project. When I saw my old friend, I hugged her and buried my face in her fleecy cheek. I was told that Babs had survived a rough winter but would likely not see another one. On that day, though, she seemed robust and cheerful. I watched as she devoured her supper, and afterward I picked sparkles from her fur. Her nose was as velvety as I had remembered.

The following month, Babs's laminitis worsened considerably. Her caregivers and veterinarian decided it was time to end her suffering. On her last day, Babs was fed delicacies that had previously been off-limits because of her Cushing's disease. She ate strawberries, peaches, watermelon, gingersnaps, peppermints, crackers, and apple pie. Staff and volunteers visited her throughout the afternoon to shower her with love. Reinvigorated by the attention, she rolled on the ground with joy and miraculously righted herself without assistance. Her passing was quick and serene.

For weeks after her death, Babs's stall was left untouched. Her boots were arranged in a corner with her blanket and her grazing muzzle hung on the wall. Mourners left roses and sunflowers on the ground where Babs had slept.

A few months later, a traumatized llama named Phyllis moved into Babs's stall. She had been horribly neglected by three separate owners and was understandably terrified of humans. Although her caregivers have their work cut out for them, their memories of Babs sustain their hope that one day Phyllis too will find peace.

## ASH

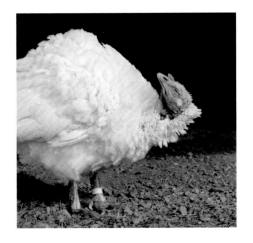

As I worked on this book I developed a deep affection for turkey hens. I love everything about them, from the powdery soft skin on top of their heads to the sweet trills they make when they are happy to the way their feathers glow in the sunlight.

The first hen I ever met was Ash (plates 11 and 12), an elderly Broad Breasted White turkey who lived at Farm Sanctuary's shelter in Orland, California. I was immediately drawn to her expressive eyes; they conveyed a quiet strength that belied her physical frailty. Her rumpled neck feathers also made me smile: they reminded me of my tousled tresses when I get out of bed in the morning.

When I first entered Ash's yard, several members of her flock hastily retreated to their barn. Not Ash. She continued grooming her feathers and did not spare me a single glance. I plopped down next to her, and we sat together drowsily soaking up the morning sun.

Even while sleeping Ash delighted me. Most birds snooze with their beaks nestled into their back feathers. Ash began her naps this way, but then she would untuck her beak and gradually arch her neck away from her body until her head tilted backward. Eventually she would startle, open her sleepy eyes, and sigh as she returned her beak to her feathers. Moments later the process would begin anew. I was thoroughly charmed by this quirky behavior and spent many hours watching her sleep.

As with a lot of rescued animals, not much is known about Ash's life before she arrived at Farm Sanctuary. Her body, though, bore telltale signs that she had been reared on a factory farm. The tip of her beak had been severed, and her middle toes had been partially amputated.

Commercially raised turkeys and chickens live in large, windowless sheds so densely crowded that the birds cannot walk without stepping on each other. There is no room for preening, foraging, or perching.[2] Birds living in these conditions are so stressed they become abnormally aggressive and even resort to cannibalism. Rather than improving the animals' living conditions, farmers try to minimize the damage the birds can inflict on each other by debeaking and detoeing chicks within days of their hatching.[3]

It's worth noting that "cage-free" and "free-range" birds are also subjected to these painful procedures. Birds living in jam-packed sheds are technically "cage-free," even though they might have no more space than their caged counterparts. Free-range birds often live in cramped conditions as well. As far as the USDA is concerned, as long as birds are granted "access to the outdoors," their meat and eggs can be sold as free-range.[4] All this means is that the birds must reside in a shed with a door that leads to an outdoor enclosure. The USDA provides no specifications regarding the size of the door or how long that door must remain open each day. There are also no requirements regarding the outdoor yard's capacity, so these spaces can be quite small, with space for only a few birds at a time.[5] As a result, many "free-range" birds never experience any time outdoors in their lives. Not all egg and poultry producers play fast and loose with these terms, but most do. And even on farms where birds can spread their wings, take dust baths, and roost, debeaking and detoeing are commonly performed.[6]

Rescued birds who have been debeaked have difficulty drinking and eating and are more lethargic than those with intact beaks.[7] Those who have been detoed

tend to develop arthritis, and Ash was no exception. She moved slowly, yet still, to me, she seemed graceful.

When I returned home from Orland, I sponsored Ash's care through Farm Sanctuary's "Adopt a Farm Animal" program. I received a card in the mail with her photo and an "Adoption Certificate" with details like her favorite food (squash) as well as adjectives describing her personality ("shy, sweet, and adorable"). Friends who worked at Farm Sanctuary kept me apprised of how she was doing, and nearly a year later, they emailed me with the news that she had passed away. Her arthritis had become too severe to treat and euthanasia was the only humane option left.

When I met Ash, I knew she was old and frail and would not live much longer. Nonetheless her death hit me hard and still today I get teary when I look at her portraits. I am grateful though for the time we shared, which inspired my love of turkeys.

## MELVIN

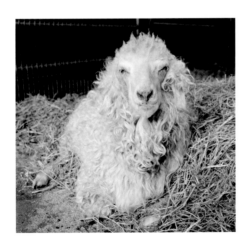

Melvin (plate 13), an Angora goat, spent the first six years of his life tethered to a tire in a barren yard. He had no shelter during the scorching summers or the rainy winters that typify California's Sacramento Valley, where he lived. One blazing hot day, a local woman drove past Melvin's enclosure and pulled over to check on him. Horrified to find he had no water, she contacted law enforcement and kept calling until they finally intervened.

Most animals are wary of people when they are first rescued. Melvin exhibited no such shyness. When Farm Sanctuary employee Kerrie Wooten picked him up from the local SPCA, he leapt into her van without any coaxing, as if he understood his worst days were behind him.

Melvin arrived at the shelter severely malnourished and lice infested. His hair was so matted it took sanctuary staff two days to shear him. Having endured years of confinement, his muscles had atrophied and his legs were arthritic. With physical therapy he became stronger, and sanctuary staff managed his arthritis with anti-inflammatory medications mixed with molasses (which goats find irresistible). Once his health improved, Melvin's sociable and curious personality

emerged. Despite—or perhaps because—he had spent his early life in isolation, he craved human affection. He always welcomed sanctuary staff by popping his head through the railings of his gate as they approached his enclosure. (To my delight, he began greeting me the same way by the end of our first day together.)

Melvin's friendliness posed a considerable challenge when I tried to photograph him. Whenever I knelt on the ground, he trotted up to chew my hair and paw at me until I petted him. Many of our photo sessions were not terribly productive, but at least we had fun.

Melvin lived with Farm Sanctuary's "special needs" herd, which consisted of older sheep and Cecil, a 14-year-old LaMancha/Saanen crossbreed goat whom I also photographed for this book (see plate 43). When I first entered the barn where the two goats lived, the sheep bolted outside. "Was it something I said, guys?" I asked as they thundered past me. I was not the least bit surprised by their reaction though: as prey animals, sheep have strong flight instincts. It often takes days for a herd to acclimate to my presence, and even then, I never truly feel welcomed (unless I come bearing molasses-laden treats).

Today, though, I intended to focus on Melvin and Cecil, so I ignored their skittish roommates. Hours passed and it was getting late. I was looking at Melvin through my viewfinder, intent on composing a few final images in the waning daylight, when all of a sudden I felt a moist hot breeze on my arm. I turned around to discover twenty-five sheep calmly staring at me. The ewe closest to me gently bumped her head against me and licked my sweaty arm. She lay down next to me and the rest of the herd drew closer, absorbing me into its midst. We remained that way until the sun set.

## TERESA

On an unseasonably muggy September morning in 2010, I visited Farm Sanctuary's shelter in Watkins Glen, New York, to meet Teresa (plate 15), a 13-year-old Yorkshire pig. She was luxuriating in a wallow when I entered her enclosure. My guide, Farm Sanctuary National Shelter Director Susie Coston, informed me that pigs lie in mud to stay cool because they do not sweat. Mud also acts as a sunscreen to protect their sensitive skin, which is similar to ours.

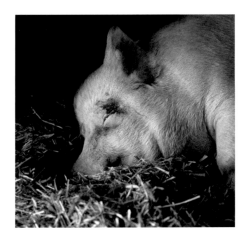

Teresa got up slowly—a telltale sign of the arthritis that afflicted her legs. She shook like a wet dog and walked up to Susie hoping for treats or a petting and found both. She grunted in rapid succession, "*ah, ah, ah,*" which I was told is a greeting reserved for friends, especially ones carrying goodies.

There was a beach ball in the yard, which caught Teresa's eye. She used her snout to push it up and down a small hill, trotting after it when it got away from her. Her joint stiffness dissipated. Eventually she entered her barn and settled onto a pile of hay. Her grunts became softer and less frequent as she sleepily basked in the sun streaming through the open door. I lay on the ground and spent the next few hours photographing her.

Afterward, I learned from Susie that Teresa had been reared on a factory farm in North Carolina. At six months of age, she was placed on a crowded trailer that was headed to a slaughterhouse in Pennsylvania. Along the way, the driver stopped at a bar in Washington, DC, parking his triple-decker truck on a city street. The pigs were left for hours in the summer heat with no air conditioning and no water. Over the next several hours, the Washington Humane Society received many calls from worried bystanders who heard loud squeals coming from the truck. Law enforcement seized the truck and brought it to the Poplar Springs Animal Sanctuary in Poolsville, Maryland.

Rescuers had a hard time getting Teresa and the other pigs out of the large trailer. The truck had no ramps so workers had to build them. Convincing the pigs to walk off the truck was another hurdle; many were so obese they had difficulty moving. All the animals were dehydrated and several were sick with pneumonia. Covered in urine and feces, they trembled uncontrollably from fever and fear. Though some of the pigs died, most survived, and forty pigs, including Teresa, were taken to Farm Sanctuary.

Because of Teresa's upbringing—or lack of it—she had to learn basic pig behavior. She was afraid to walk on grass, having never encountered it before. She tried to eat dirt, not knowing what it was. Other behaviors like nest building and wallowing came naturally.

Teresa was quite shy until she was befriended by a gregarious pig named Howard. Because of his outgoing nature, Howard helped Teresa learn to trust humans.

When sanctuary staff visited the pair, he approached them first, with Teresa following behind. Years later, Howard died of liver failure, leaving Teresa adrift.

There is little doubt that pigs are capable of grief. I have heard numerous stories from animal care workers about pigs shutting down after a parent or friend dies. When this happens, they isolate themselves, stop eating, and spend most of their time sleeping. On occasion, the grief becomes so debilitating that the pig dies. Fortunately, this did not happen with Teresa. She took solace in her friendship with Dale, another pig who had been rescued with her in Maryland. The pair lived for several years in the sanctuary's "retirement barn" for older pigs until he too passed away. One by one Teresa's other friends died, and each loss seemed to weigh heavily on her. Hoping to lift Teresa's spirits, Susie introduced her to a younger pig named Harry, whose mother had recently died from cancer. The two instantly hit it off and became inseparable.

Prior to my visit, Harry was moved to an adjacent pen to keep him from photo bombing my portraits of Teresa. As I photographed his friend, he watched closely from the other side of the fence. When Susie opened the gate after I finished, he made a beeline for Teresa. As we watched the pair snuggle, Susie revealed that Teresa had uterine cancer that had spread to her breasts. The cancer was growing slowly, but Susie did not think Teresa had much time left.

Ultimately it was not cancer but arthritis that led to Teresa's death. This is the most frequent cause of death for pigs rescued from factory farms. Even with the proper diet and exercise they receive at sanctuaries, they cannot escape their breeding, and they reach weights their joints cannot sustain. On a late autumn day a few years after I met her, Teresa was euthanized surrounded by the staff members who adored her. Harry lay next to her as she drifted off to her final sleep.

## VALENTINO

Photographing Valentino (plate 19) was a life-altering experience. I had been a vegetarian for fifteen years and thought that I consumed a humanely produced diet. I purchased organic dairy products that came from grass-fed cows who were not given bovine growth hormones. But I had never contemplated what happens to cows after they no longer produce milk; nor did I consider the fate of male

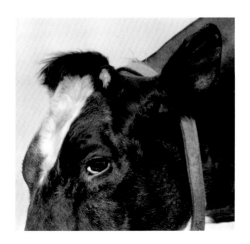

calves in the dairy industry. Then I met Valentino, a dairy industry survivor whose life would have been brief and miserable had he not been rescued. Because male calves do not produce milk, they hold little value for dairy farmers. Some are reared for breeding purposes, but millions each year are sold to beef or veal producers.[8] Sickly calves are killed or hurled onto "dead piles," where they are left to die.[9] This would have been Valentino's fate had he not been surrendered to a nearby SPCA.

Valentino was a frail two-week-old calf when he arrived at Farm Sanctuary's shelter in Orland, California. He had been born with lax tendons that prevented him from walking and required months of physical therapy. Animal caregiver Diane Miller provided him with round-the-clock care during his first few months at the sanctuary. Several times a day, Diane used a bottle to entice Valentino to walk a few short steps and then she rewarded him with milk. Her dog Sunshine became fast friends with the calf, and the two animals played tug of war with Valentino's leash. At first the puppy won these contests, but eventually the young steer prevailed.

Valentino made a full recovery, and within a few years, this scrawny calf became a 2,500-pound gentle giant. Despite his heft, he remained playful and goofy and became close friends with fellow Holsteins Joni and Henry. His coat was nearly always covered in cowlicks thanks to Joni's affectionate grooming. He never forgot Diane and Sunshine, though, and he trotted to meet them whenever they entered his pasture.

As he aged, Valentino developed arthritis in his hips and hind legs, common ailments for elderly Holsteins. He was moved to the sanctuary's "special needs" herd for older cows and for those with medical issues that require close monitoring. Animal care workers successfully managed his arthritis for several years with anti-inflammatory and pain medications. As cows age, their teeth wear down, impacting their ability to chew and digest hay and grass. To supplement his diet, Valentino was treated to a mash of watered-down feed pellets sweetened with molasses. He also adored carrots, and despite having arthritis, he routinely trotted to greet any visitors in hope of receiving some.

I met Valentino when he was 19 years old, and he was the longest living Holstein that Farm Sanctuary had ever cared for. While photographing him, I wondered how many cows were denied old age because I enjoyed cream in my coffee and

butter in my mashed potatoes. After I finished, I hugged him and spent time petting his soft cheek. He licked me, and his tongue had the same sandpapery texture as my cats' tongues. In that moment, I knew I could no longer consume dairy products. Upon returning home, whenever I was tempted by the sight of a buttery croissant or the sharp aroma of Pecorino Romano, I conjured memories of my afternoon with Valentino and recalled his story. Nine years later, I no longer yearn for dairy products, but I still miss my friend's presence whenever I visit Farm Sanctuary.

# What Farm Sanctuaries Teach Us

GENE BAUR

I grew up in Hollywood, California, near Griffith Park, and as a young boy, I witnessed nature and animals harmed by human activities. I was viscerally upset to see old trees cut down and wild animals injured, including a deer entangled in a chain-link fence in a neighbor's yard who had to be killed. I didn't want to be a cog in a wheel of a system that was causing so much pain and destruction.

Throughout high school and college, my desire to live without causing unnecessary harm evolved, and I began exploring ways to address and resolve problems stemming from human activities and institutions. I stopped eating veal in high school when my grandmother told me how veal calves suffered, chained by their necks in crates for their entire lives. I went vegan in college after I learned about the inefficiency and environmental destruction caused by animal agriculture.

When Farm Sanctuary was founded in 1986, there was very little awareness about the widespread suffering animals experience on factory farms. Cofounder Lorri Houston and I sought to expose this cruel industry by investigating farms, stockyards, and slaughterhouses to document conditions, and we found living animals discarded in trash cans or on piles of dead animals. From our discoveries, our shelter operations were born. At first, we operated out of donated space in a row house in Wilmington, Delaware, then on a few acres near Avondale, Pennsylvania, before acquiring our first permanent sanctuary in 1989, a 175-acre farm, near Watkins Glen, New York.

Our first rescued animal was a sheep named Hilda. On a muggy summer day, we found her lying amid the rotting carcasses of sheep, pigs, and cattle piled behind Lancaster Stockyards in Pennsylvania. It was shocking to find a living creature treated with such disrespect. We could not leave her there to die a slow and agonizing death, so we took her to a local veterinarian. We were surprised by how quickly she recovered after receiving basic care, water, and food. We brought her home and she lived with us for more than ten years. Hilda was shy and reserved, and her life was enriched by her lifelong companionship with another rescued sheep named Jellybean, who was more gregarious. Jellybean helped Hilda become more comfortable around people. As Jellybean approached visitors, Hilda also moved closer. They were constant companions and lived long peaceful lives together before dying of old age.

When animals arrive at Farm Sanctuary, they are given food, shelter, and medical care, and they are allowed to live out their lives in peace. Cows and sheep

wander and graze in open pastures; goats browse and some even climb trees; pigs root in the soil and wallow in ponds; chickens dust bathe and perch. They are all free to play and express their individuality. The animals communicate their likes and dislikes, and they develop friendships and relationships. They become our cherished companions; we have turkeys that follow us like puppies, looking for a chance to sit on our laps.

Farm sanctuaries didn't exist in the early 1980s, but today there are hundreds (possibly even thousands) of them across the US and around the world. These shelters present a new model for how we can interact with farm animals as our friends, not our food. Visitors are encouraged to meet and get to know these animals as living, feeling creatures with complex cognitive and emotional lives, and to recognize that each is an individual with his or her own personal experience and story. We encourage people to connect with farm animals and to recognize that they are similar to the cats and dogs who live with us in our homes. Many then reflect on inconsistent societal norms whereby certain animals are treated as members of our families, while others are warehoused in crowded factory farms and then killed for food.

Farm sanctuaries are a blatant affront to the systemic cruelty and violence of a heartless industry that regards animals as commodities and packs them in cages and crates so tightly they can barely move. These frustrated, immobilized animals suffer physical and psychological distress, and clank against the bars of their enclosures, desperately seeking release. Visiting factory farms fractures your soul, while breathing the filthy air and toxic fumes burns your eyes, nose, and throat. Pigs, cows, chickens, and other animals are treated like inanimate tools of production and live in misery from their first day on earth until they meet their bloody end at the slaughterhouse. While it's hard to grasp the enormity of billions of animals—trillions if you include fish—who are exploited and killed for food every year, we need to remember that each is an individual, and each experiences his or her own life in a very real and personal way.

Rescuing animals from factory farms and slaughterhouses and watching them heal has helped me cope with the immense trauma I witnessed during undercover farm investigations. Saving animals from cruelty is an immediate and concrete response to an unconscionable industry, and focusing on these rescues can provide solace in the midst of vast suffering. Knowing I could return home to

be with these survivors also gave me strength to continue the work I was doing. Spending time with Isa Leshko's images has a similar effect on me.

Isa pays careful attention to her animal subjects and sees them for the individuals they are. Her images embody the animals' characters, showing that they are someone, not something, and that each is deserving of our consideration and respect. I'm moved by her images of elderly farm animals, which personify each animal's beauty, frailty, and wisdom. Among those I find particularly touching is her image of a rooster (see plate 1). These animals are refugees who've escaped slaughter to live full, dignified lives, free of the cruelty and violence that is imposed on their kind as a matter of course. They are the few survivors, and we are enriched by our kinship with them.

Farm sanctuaries can only rescue a tiny fraction of the billions of animals who deserve reprieve. They are safe spaces, and their example calls us to question the assumptions and prejudices most of us grow up with about farm animals. Farm sanctuaries assert that farm animals, like all animals, are individuals who deserve our compassion and respect, and that caring for refugees of an abusive system awakens the best of our humanity. By meeting cruelty with kindness and aligning our actions with our empathy, we help animals and also find wholeness in ourselves.

# Empathy That Became Advocacy

ANNE WILKES TUCKER

Isa Leshko primarily photographs animals who have been bred to breed other animals, to produce food (such as eggs or milk), or to become food, but she chooses to focus on those beings in the late stages of their lives. This is a distinct, relatively unknown segment of the animal kingdom because aged farm animals are rare. Most are killed before they are six months old. The beings in her portraits range from 8 to 33 years old, their "elderliness" being relative to the life expectancy of their breed and the quality of their lives before rescue.[1] All came from situations that ranged from distressing to brutal.

Leshko works with farm animal sanctuaries, a relatively new and small network of independent, nonprofit organizations founded to protect animals from cruelty, abuse, and slaughter.[2] The first of these to begin operations was Farm Sanctuary, cofounded in 1986 by Lorri Houston and Gene Baur, one of many animal rights activists who worked with Dr. Alex Hershaft. Ten years earlier, guided by an abolitionist vision of a world where animals are free from all forms of human exploitation, including being used for food and clothing, research and testing, entertainment and hunting, Hershaft had founded the Farm Animal Rights Movement (FARM). Working within the vision of nonexploitation, farm sanctuaries seek to rehabilitate ill or abused animals and provide them with pastures and shelters where they can live with minimal intervention from humans. Leshko has photographed the animals who reached old age while living in the sanctuaries.[3]

The seeds for this project took root while Leshko cared for her mother through a long-term battle with Alzheimer's disease before her eventual death. Although Leshko thought about documenting her mother's prolonged stages of deterioration, she decided not to. Only later, when she was drawn to photograph aging and dying animals—first in a friend's pasture and then in the sanctuaries, did Leshko connect these impulses to her experiences of caring for her mother as well as to her own fears of aging and developing dementia. In the early stages of this project, photographing elderly decline in animals in some ways replaced the pictures she didn't take of her mother's degeneration, and raised many of the same issues, such as their having proper care and assuring death comes with all possible dignity. The animals were simultaneously symbols of her personal crisis as well as individual beings with whom Leshko bonded as she worked through the intricate processes that she devised to make their portraits. Eventually she pulled away from projecting her "emotional baggage about aging" onto the animals because "treating these animals as proxies for my own concerns about mortality seemed exploitive."[4] As the project evolved and she heard the stories of the rescued

animals, using her photographs to advocate on the animals' behalf became a critical part of the project.

An early and continuing concern for Leshko was the matter of consent, which arose from her understanding of her mother's intense pride in her appearance when in public. Once her mother lost cognizance, she was defenseless against any images that might be made of her in her terminal state, which is one reason why Leshko chose not to photograph her. While animals cannot express consent, they have intelligence and feelings, which scientists and animal handlers have been able to confirm, if not always measure with precision. So Leshko sought to limit their discomforts and any disruption in their lives that she might engender while photographing them.

Because these particular animals are physically and, potentially, emotionally fragile, she often spends time with them before introducing a camera into their private space. To build trust, she sometimes made multiple visits, becoming increasingly attached, which intensified her grief when they inevitably died, sometimes shortly after a portrait was made. Her feelings for them as individuals with names also led her to photograph some of them at eye level, which at times requires her to lie on the ground or barn floor. For instance, the viewer is face to face with Bogart, a 16-year-old Santa Cruz sheep who has not been shorn (plate 22), Bessie, a 20-year-old Holstein cow (plate 9), and Melvin, an 11-year-old Angora goat (plate 13).[5] Each one stares directly at the camera, but with lethargic tolerance, not the energetic curiosity of a younger animal. Leshko frames the pictures to make it clear that Bogart, Bessie, and Melvin each lie in a bit of warm sunlight, their beds of hay are clean, the air is fresh, and their quarters are generous.

Without captions, viewers may have difficulty reading these animals' signs of aging, at least not as easily as they can identify geriatric telltales in humans, such as gray and thinning hair, loss of skin tone at the joints, age spots, and clouded eyes. Actually, most of the same conditions exist in animals. The quality of their hair and feathers deteriorates, as is dramatically evident in the portraits of a rooster of an unknown age (plate 1) and of Ash, an 8-year-old domestic turkey (plates 11 and 12). For other animals, the eyes are cloudy and hearing is diminished, as is mobility and balance. For instance, Violet, a 12-year-old potbellied pig struggles to hold an upright position. Yet Leshko conveys a sense of Violet's determination and independence (see plates 34 and 35). While some subjects

project resolve, others seem to have peacefully yielded to gravity's power over their compromised strength.

Leshko's deep reading on photography, animal behavior, animal rights movements, and human tendencies to anthropomorphize animal behavior have affected every decision she has made in this project. She has paid particular attention to the works of photographers of animals and portraitists, especially those who photographed elderly subjects. Many photographers have considered photographing terminally ill members of their family and, like Leshko, decided to abstain. Others have regarded as natural their impulses to employ their cameras to confront a situation in which they were otherwise powerless. Richard Avedon and Keith Carter are among the photographers who made the latter choice. Avedon portrayed his father, Jacob Israel Avedon, from 1969 to 1973, selecting seven likenesses from many images taken to document the transformation of a well-dressed man with apprehensive but appraising eyes into one who was a frail ghost of his former self. In the last picture, his father lacks energy and seems resigned to both his ill health and his son's probing camera.

In a description of the final portraits, Avedon distances himself from the images, writing, "They seem now, out of the context of those moments, completely independent of the experience of taking them. They exist on their own. Whatever happened between us was important to us, but it is not important to the pictures. What is in them is self-contained and, in some strange way, free of us both."[6] Keith Carter's motivation to photograph the terminal declines of both his mother and his wife Pat was conversely personal at all stages. "If photography is an intimate part of your life," said Carter, "a photograph is the talisman that means the most, certainly for me. In my wife's case, it was part of the progression of our forty years. At the end of mother's life, she was not cognizant, so she couldn't give her permission, but she had supported herself as a photographer and taught me to photograph. She would have understood that I wanted physical proof of that lovely relationship and how beautiful she was to me in those final moments."[7]

Leshko's approach to photographing animals falls between Avedon's cool analysis and Carter's sweet remembrances. Carter has also photographed many animals in good health, during recovery, and deceased. For him, like Leshko, these images are portraits and require the same intense concentration that he would bring to any graphic rendering. In conversation, Leshko brought up Carter as

someone whose work she admired, in part for his capacity to convey respect for his subjects, whether they were two-legged or four.[8] Like Carter, initially, she may be emotionally drawn to subjects, but, like Avedon, she prefers to work in a careful and cool manner. However, she draws a line. "Maintaining the dignity of the animals I have photographed is important to me," she wrote, "even if that means the images lack the unflinching power of Avedon's portraits of his father."[9]

She regards her pictures of animals as portraits with all the attributes of the genre. They are carefully constructed, and not taken without the sitter's awareness and some semblance of cooperation. The animals are the purpose and obvious focus of the pictures. Out of respect, her compositions and featured details do not exaggerate the animals' ailments or the effects of aging. Her conviction that these subjects are worthy of the viewers' consideration is consummated in the care she takes to make tonally rich, meticulously printed, and visually seductive prints from her negatives. In explaining the potential dichotomy between confrontational and potentially disturbing images and making exquisite prints, she cites photographer Richard Misrach's explanation of his colorfully rich, almost searing images of dead animal disposal sites and toxic waste dumps. Speaking to the *New York Times*, Misrach asserts that if he made ugly pictures of these subjects, no one would take time to seriously question why he made the pictures. "It's the way the story is told that makes us re-examine life afresh," commented Misrach.[10] Leshko continued that, like Misrach, she employed notions of classical beauty to draw people to her images.

Misrach and Leshko also share advocacy as a component of their photographic practice. He campaigns for the environment; she wants her photographs to evoke changes in public attitudes toward animals. She is a vegan, wants others to give up eating meat, and hopes her pictures will be the catalyst. "As people linger over my animal portraits," she wrote in a grant application, "they begin to appreciate the lives of farm animals, perhaps for the first time. This heightened consciousness will hopefully lead them to contemplate the effect their behavior has on the treatment of animals."[11] This may be wishing for more than her pictures can deliver, which does not mean they are powerless. They can engender different actions, starting with empathy and the capacity not to look away from hard situations where no personal obligation compels one's attention.

It is possible that some viewers don't want to see what Leshko's images offer, which are beautiful and respectful portraits of animals at the ends of their lives.

Their proximity to death can be disturbing rather than endearing for some viewers. Among those interviewed for this essay was animal rights sponsor Don Sanders, who stated, "Animals, especially injured and abused animals, have no hope without our help. We can give them a second chance, but I don't like to see them in their injured state. I don't watch the negative, but I know it does spur others to respond."[12] Sanders and many others in the animal protection movement particularly abhor photographs of tragically mistreated, starved, and infested domestic pets such as those shown on late night television as advertisements to raise funds for the national SPCA.[13] These pictures are dramatic and grossly exploitive, but Leshko's response to them is complicated and mixed because "the use of images of animal suffering can be a powerful advocacy tool."[14] Other animal protection organizations, particularly those urging viewers to adopt the featured animals, to donate toward their upkeep, or to attend lectures and tours at their facilities, believe that most effective way to meet their goals are with images of animals in recovery, with reasonable hope of recovery, or already with a loving new owner. Some farm sanctuaries do not offer their animals for adoption, certainly not into domestic situations. Instead, the animals are given living accommodations appropriate to their elderly status in which to complete their lives. The farm sanctuaries that do offer adoption also seek appropriate environments.

While some of the photographs used for advocacy by animal protection organizations are perceptive, well-crafted, and effective for the organizations' needs, few match Leshko's meticulously crafted prints of images that invite empathy and yet can be provocative enough to evoke change—personal and, potentially, social. It is Leshko's absorption of photography's history and mastery of its aesthetics that sets her work apart, as well as the surprising engagement of her chosen subjects.

# Notes

1.  One particularly horrific case occurred in 2012 at an egg production facility near Turlock, California, in which 50,000 hens were left without food or water for at least two weeks. More than 40,000 birds were found dead from various causes, including starvation, dehydration, cannibalization, and infection. Several thousand more were euthanized to end their suffering. The remaining 4,500 chickens who survived were surrendered to three sanctuaries in California: Harvest Home Animal Sanctuary in Stockton; Animal Place in Grass Valley; and Farm Sanctuary in Orland. The three sanctuaries rehabilitated the survivors and provided them with permanent homes. See John Holland, "Parties Settle Civil Case over Starving Chickens near Turlock," *Modesto Bee*, August 21, 2014, http://www.modbee.com/news/local/article3170263.html. See also John Holland, "Witness Tells of Troubling Scene at Stanislaus County Egg Farm," *Modesto Bee*, May 26, 2015, http://www.modbee.com/news/article22391538.html.

2.  "An HSUS Report: The Welfare of Animals in the Chicken Industry," Humane Society of the United States, http://www.humanesociety.org/assets/pdfs/farm/welfare_broiler.pdf.

3.  "An HSUS Report: The Welfare of Animals in the Pig Industry," Humane Society of the United States, http://www.humanesociety.org/assets/pdfs/farm/welfare_pig_industry.pdf.

4.  Although sanctuaries seem like idyllic places, the animals who live there are still in captivity and their caregivers grapple daily with ethical dilemmas related to their care. Miriam Jones, the cofounder of VINE Sanctuary, writes, "Certainly true freedom escapes almost all farmed or formerly farmed animals. We [at VINE] use the term 'as free as possible' deliberately, as fences, enforced routines, involuntary medical procedures and regimes (including everything from forced sterilization to force feeding), and other impositions certainly do not comprise a free state of being for those on the receiving end. . . . We justify these decisions because the alternatives are unacceptable. We live in a world that requires the rescue of members of certain species because other members of our species will hurt and kill them if we don't." Miriam Jones, "Captivity in the Context of a Sanctuary for Formerly Farmed Animals," in *The Ethics of Captivity*, ed. Lori Gruen (New York: Oxford University Press, 2014), 91–92. For an overview of the ethical concerns relating to sanctuaries, see Sue Donaldson and Will Kymlicka, "Farmed Animal Sanctuaries: The Heart of the Movement? A Socio-Political Perspective," *Politics and Animals* 1 (2015): 50–74.

5.  On commercial dairy farms, calves are separated from their mothers within a few hours of their birth, which is quite traumatic for the animals involved. Female calves are reared to become dairy cows; male calves are typically sold to the veal industry, where they will lead short, miserable lives in strict confinement. See "An HSUS Report: The Welfare of Animals in the Veal Industry," Humane Society of the

United States, http://www.humanesociety.org/assets/pdfs/farm/hsus-the-welfare-of-animals-in-the-veal-industry.pdf. See also "An HSUS Report: The Welfare of Cows in the Dairy Industry," Humane Society of the United States, http://www .humanesociety.org/assets/pdfs/farm/hsus-the-welfare-of-cows-in-the-dairy-industry.pdf.

6. In 2018, Farm Sanctuary closed its shelter in Orland, California, and relocated the resident animals to their shelters in Acton, California, and Watkins Glen, New York.

7. "Legal Protections for Animals on Farms," Animal Welfare Institute, https:// awionline.org/sites/default/files/uploads/documents/FA-AWI-LegalProtections-AnimalsonFarms-110714.pdf.

8. For details, see the Global Federation of Animal Sanctuaries website: https://www .sanctuaryfederation.org.

9. A how-to guide on the Farm Sanctuary website has the following warning: "One of the biggest pitfalls for shelters is taking in too many animals too soon. If you take in animals before obtaining funds, you will never find the time to raise money neces-sary for their care. Always expect extra costs. Because most of the animals you take in come from bad situations, you will probably be dealing with many health issues; this can deplete your budget quickly. We want to save every animal but doing so is not feasible; you will end up using all your time and resources providing inadequate care." "How to Start, Operate, and Develop a Farm Sanctuary," Farm Sanctuary, http://www.farmsanctuary.org/wp-content/uploads/2012/03/How-to-Start-a-Farm-Animal-Sanctuary-single-1-Final.pdf. Farm Sanctuary hosts an annual conference on farm animal care designed to train attendees on the fundamentals of operating a farm animal sanctuary. For details, see the Farm Sanctuary website: https://www. farmsanctuary.org/events/farm-animal-care-conference/. In addition, many farm sanctuaries offer internships that provide hands-on training in animal welfare, marketing, and fundraising.

10. "U.S. Broiler Chicken Performance," National Chicken Council, https://www .nationalchickencouncil.org/about-the-industry/statistics/u-s-broiler-performance/.

11. "The Welfare of Animals in the Turkey Industry," Humane Society of the United States, http://www.humanesociety.org/assets/pdfs/farm/HSUS-Report-on-Turkey-Welfare.pdf.

12. Ibid. See also James G. Dickson, ed., *The Wild Turkey: Biology and Management* (Me-chanicsburg, PA: Stackpole Books, 1992), 34.

13. For a moving discussion of how sanctuary staff mourn the animals they have cared for, see patrice jones and Lori Gruen, "Keeping Ghosts Close: Care and Grief at Sanc-tuaries," in *Mourning Animals*, ed. Margo DeMello (East Lansing: Michigan State University Press, 2016), 187–92.

14. Pasado's Safe Haven in Sultan, Washington, maintains a large memorial garden with tombstones honoring their departed residents. Each stone contains a phrase

that reflects the personality of the deceased. Some of these memorials are poignant. For example, the marker for Bessie, a Holstein cow (see plate 9) reads:

*Our Bessie*
*Forever a loving mom*
*and the strongest lady we know*

Others are playful:

*Nora Pig*
*Lived her life full of sass*
*Knocked her vet on her ass*

Or:

*Peach Pie Pony*
*The Most Badass*
*Punk Rock Unicorn*
*You are missed*

15. Lori Gruen writes, "In captivity, we can respect the wild dignity of animals by allowing them to be seen only when they wish to be seen and recognize that their lives are theirs to live without our judgments or interference." Lori Gruen, "Dignity, Captivity, and an Ethics of Sight," in *Ethics of Captivity*, ed. Lori Gruen (New York: Oxford University Press, 2014), 245. See also Brett Mills, "Television Wildlife Documentaries and Animals' Right to Privacy," *Continuum* 24, no. 2 (2010): 193–202.
16. Susan Sontag, *On Photography* (New York: Picador, 1973), 14.
17. Matthew Brower, *Developing Animals: Wildlife and Early American Photography* (Minneapolis: University of Minnesota Press, 2011), 39–46.
18. Ibid., 33.
19. Ibid., 46–54.
20. Catherine Evans, "Pictures in Pictures," in Shelby Lee Adams, *Salt & Truth* (Richmond, VA: Candela Books, 2011), 12.
21. Steve Baker, *Picturing the Beast: Animals, Identity, and Representation* (Champaign: University of Illinois Press, 2001), 193. On page xxvi of the paperback edition that was published eight years after the original edition, Baker admits that he was too hasty to dismiss animal-themed artwork: "Written at the start of the 1990s, *Picturing the Beast* had little to say about the animal's typical role in fine art imagery, but I nevertheless took a rather dim view of such art, associating it with cuteness and kitsch. In retrospect that seems to have been a mistake."

22. Artist Charlotte Dumas met similar resistance when she began photographing animals in art school. See Conor Risch, "A Fine Art Approach to Photographing Animals," *Photo District News*, June 15, 2012, https://www.pdnonline.com/features/a-fine-art-approach-to-photographing-animals. See also Sarah Phillips, "Photographer Charlotte Dumas's Best Shot," *Guardian*, April 11, 2012, https://www.theguardian.com/artanddesign/2012/apr/11/charlotte-dumas-best-shot-photography.

23. In an interview with art historian Steve Baker, artist Sue Coe articulates the inherent problems with using animals as metaphors: "By using an animal or its (image) as a symbol of or for something else, that animal is effectively robbed of its identity, and its interests will thus almost inevitably be overlooked." Steve Baker, "You Kill Things to Look at Them: Animal Death in Contemporary Art," in *Killing Animals*, ed. The Animal Studies Group (Champaign: University of Illinois Press, 2006), 78. See also Yvette Watt, "Making Animals Matter: Why the Art World Needs to Rethink the Representation of Animals," in *Considering Animals: Contemporary Studies in Human-Animal Relations*, ed. Carol Freeman, Elizabeth Leane, and Yvette Watt (Burlington, VT: Ashgate, 2011), 119–34.

24. Richard Avedon, *Marilyn Monroe, Actress, New York* (1957). See the Richard Avedon Foundation website, https://www.avedonfoundation.org/the-work/.

25. Maria Morris Hambourg and Mia Fineman, "Avedon's End Game," in *Richard Avedon Portraits*, Richard Avedon (New York: Harry N. Abrams / Metropolitan Museum of Art, 2002), 10–11.

26. From its inception in the early twentieth century, animal behavioral science rejected the idea that animals were capable of thought or emotion. Instead, all animal behavior was deemed the result of hard-wired reflexes or learned associations between positive or negative stimuli. Over the last three decades, this theory has been challenged by research in the fields of evolutionary biology, cognitive ethology, zoology, and neuroscience. Although some behaviorists still resist attributing "human-like" mental processes to nonhuman animals, the prevailing view is that psychological continuities exist among all vertebrates and many invertebrates (e.g., cephalopods). Carl Safina writes, "Parental care, satisfaction, friendship, compassion, and grief didn't just suddenly appear with the emergence of modern humans. All began their journey in pre-human beings. Our brain's provenance is inseparable from other species' brains in the long cauldron of living time. And thus, so is our mind." Carl Safina, *Beyond Words: What Animals Think and Feel* (New York: Henry Holt, 2015), 30. Readers interested learning more about in this topic may refer to titles listed under "Animal Emotions and Cognition" in the Suggested Reading section of this book.

27. Barbara J. King, *Personalities on the Plate: The Lives and Minds of Animals We Eat* (Chicago: University of Chicago Press, 2017), 193.

28. A common misconception is that dogs and cats are smarter or more emotionally sensitive than farm animals, despite ample scientific evidence that shows otherwise. "In North America and Europe, we like our dogs and chimpanzees smart

and our chickens, cows, goats, pigs, octopuses, and fish stupid," writes Barbara King in *Personalities on the Plate*. She cites a review article by Steve Loughnan, Brock Bastian, and Nick Haslam that found a negative correlation between the perceived edibility of animals and their perceived sentience. In one study cited by Loughnan et al., American subjects viewed tree kangaroos less capable of suffering and less deserving of moral concern when they were told they were consumed as food in Papua New Guinea than when they were told only that the animal resided in that region. Thinking that animals consumed for food are less intelligent than companion animals resolves the "meat paradox"—the cognitive dissonance that occurs when people who say they love animals still eat meat. See Steve Loughnan, Brock Bastian, and Nick Haslam, "The Psychology of Eating Animals," *Current Directions in Psychological Science* 23, no. 2 (2014): 104–8, as cited in Barbara J. King, *Personalities on the Plate: The Lives and Minds of Animals We Eat* (Chicago: University of Chicago Press, 2017), 196–97. For a more in-depth examination of this topic, see Melanie Joy, *Why We Love Dogs, Eat Pigs, and Wear Cows: An Introduction to Carnism* (San Francisco: Conari, 2010).

29. Susan Sontag, *On Photography* (New York: Picador, 1973), 15.

30. Roland Barthes, *Camera Lucida: Reflections on Photography*, trans. Richard Howard (New York: Farrar, Straus, and Giroux, 1981), 96.

31. Jonathan Safran Foer, *Eating Animals* (New York: Little Brown, 2009), 34.

## ANIMAL STORIES

1. Stephanie Perciful, Pasado's Safe Haven Sanctuary Director, email to author, October 3, 2017.

2. "An HSUS Report: The Welfare of Animals in the Turkey Industry," Humane Society of the United States, http://www.humanesociety.org/assets/pdfs/farm/HSUS-Report-on-Turkey-Welfare.pdf.

3. Dr. Heng-wei Cheng, "Current Developments in Beaktrimming," US Department of Agriculture Agricultural Research Service, published Fall 2010, https://www.ars.usda.gov/ARSUserFiles/50201500/beak%20trimming%20fact%20sheet.pdf. See also "Beak Trimming," Poultry Hub, http://www.poultryhub.org/health/health-management/beak-trimming/.

4. US Department of Agriculture, "Meat and Poultry Labeling Terms," US Department of Agriculture website, https://www.fsis.usda.gov/wps/portal/fsis/topics/food-safety-education/get-answers/food-safety-fact-sheets/food-labeling/meat-and-poultry-labeling-terms.

5. Jonathan Safran Foer, *Eating Animals* (New York: Little, Brown, 2009), 61. See also Animal Welfare Institute, "Petition for Rulemaking or Policy Change," US Depart-

ment of Agriculture website, January 2016, https://www.fsis.usda.gov/wps/wcm/
connect/368eba0b-4195-4641-91d7-7f772ead9a3e/16-01-AWI-Petition-012016.pdf?-
MOD=AJPERES.

6.  Stephanie Strom, "What to Make of Those Animal Welfare Labels on Meat and
    Eggs," *New York Times*, January 31, 2017, https://www.nytimes.com/2017/01/31/dining/
    animal-welfare-labels.html. See also "Farm Animal Welfare: Chickens," MSPCA-
    Angell, https://www.mspca.org/animal_protection/farm-animal-welfare-chickens/.

7.  "Welfare Implications of Beak Trimming: Literature Review," *American Veterinary
    Medical Association*, February 7, 2010, https://www.avma.org/KB/Resources/Literatur-
    eReviews/Pages/beak-trimming-bgnd.aspx.

8.  "An HSUS Report: The Welfare of Cows in the Dairy Industry," Humane Society
    of the United States, http://www.humanesociety.org/assets/pdfs/farm/hsus-the-
    welfare-of-cows-in-the-dairy-industry.pdf.

9.  Jonathan Safran Foer, *Eating Animals* (New York: Little, Brown, 2009), 56.

EMPATHY THAT BECAME ADVOCACY

1.  Chickens raised on a family farm with access to outdoor exercise have a significant-
    ly different life expectancy than chickens raised on factory farms and engineered to
    age rapidly.

2.  Euthanasia is reserved for animals who are suffering severely despite palliative care
    and those considered dangerous to public safety.

3.  The sanctuary movement is more than a hundred years younger than that of
    humane societies, the first of which opened in New York in 1866. The core of their
    differences is that sanctuary animals are not routinely euthanized, whereas in the
    humane societies, many, sometimes thousands, of healthy of animals are killed to
    control overpopulation. One common link between all animal protection groups
    is their wish to end indiscriminate animal breeding and factory-line production of
    farm animals, often in hideously cruel circumstances. The farm sanctuaries are the
    most absolute in their desire for animals to be treated as distinct individuals and
    not used for human needs or entertainment. This position also puts farm sanctuar-
    ies apart from "no-kill" animal shelters, which are primarily for companion animals
    and seek human adoptions for their wards.

4.  Isa Leshko, email to author, November 27, 2016.

5.  Leshko requested that animals be referenced as "who," not "that," "to emphasize
    that animals are sentient individuals and not objects. This syntax is consistent
    with guidelines put forth by the Animals and Media Foundation. See http://www
    .animalsandmedia.org/main/journalism-guidlines/." Isa Leshko, email to author,
    April 28, 2017.

6. ASX Team, "Richard Avedon—'Jacob Israel Avedon'" (1974), *American Suburb X*, April 8, 2011, http://www.americansuburbx.com/2011/04/richard-avedon-jacob-israel-avedon-1974.html.

7. Keith Carter, telephone interview with author, November 23, 2016.

8. Isa Leshko, conversation with author, June 11, 2016.

9. Isa Leshko email to author, June 12, 2016; modified January 26, 2017.

10. Philip Gefter, "Beauty as a Firebomb in the War on Nature," *New York Times*, February 6, 2006, http://www.nytimes.com/2006/02/19/arts/design/beauty-as-a-firebomb-in-the-war-on-nature.html.

11. Isa Leshko, grant application to private foundation, November 1, 2016.

12. Don Sanders, telephone interview with author, December 1, 2016.

13. National and local SPCA organizations are independent of each other and do not mingle funds or programs.

14. Isa Leshko, email to author, April 25, 2017.

# Suggested Reading

AGING AND MORTALITY

DeMello, Margo, ed. *Mourning Animals: Rituals and Practices surrounding Animal Death.* East Lansing: Michigan State University Press, 2016.

Gawande, Atul. *Being Mortal: Medicine and What Matters in the End.* New York: Metropolitan Books, 2014.

Gullette, Margaret Morganroth. *Aged by Culture.* Chicago: University of Chicago Press, 2004.

Hall, Donald. *Essays after Eighty.* New York: Houghton Mifflin Harcourt, 2014.

Kalanithi, Paul. *When Breath Becomes Air.* New York: Vintage, 2016.

Pierce, Jessica. *The Last Walk: Reflections on Our Pets at the End of Their Lives.* Chicago: University of Chicago Press, 2012.

ANIMAL ETHICS

Bekoff, Marc, and Jessica Pierce. *The Animals' Agenda: Freedom, Compassion, and Coexistence in the Human Age.* Boston: Beacon, 2017.

Bramble, Ben, and Bob Fischer, eds. *The Moral Complexities of Eating Meat.* New York: Oxford University Press, 2016.

Foer, Jonathan Safran. *Eating Animals.* New York: Little, Brown, 2009.

Gruen, Lori. *Entangled Empathy.* Brooklyn, NY: Lantern Books, 2015.

———. *Ethics and Animals: An Introduction.* New York: Cambridge University Press, 2011.

———, ed. *The Ethics of Captivity.* New York: Oxford University Press, 2014.

Regan, Tom. *The Case for Animal Rights.* 2nd ed., updated. Berkeley: University of California Press, 2004.

Singer, Peter. *Animal Liberation.* 4th ed. New York: Harper Collins, 2009.

ANIMALS IN VISUAL CULTURE

Aaltola, Elisa. "Animal Suffering: Representations and the Act of Looking." *Anthrozoös* 27, no. 1 (2014): 19–31.

Aloi, Giovanni. *Art and Animals.* New York: I. B. Tauris, 2012.

Animal Studies Group, ed. *Killing Animals.* Urbana: University of Illinois Press, 2006.

Armstrong, Philip. *Sheep.* London: Reaktion Books, 2016.

Baker, Steve. *Artist | Animal.* Minneapolis: University of Minnesota Press, 2013.

———. *Picturing the Beast: Animals, Identity, and Representation.* First Illinois Paperback. Champaign: University of Illinois Press, 2001.

———. *The Postmodern Animal.* London: Reaktion Books, 2000.

Berger, John. *Why Look at Animals?*, New York: Penguin Books, 2009.

Broglio, Ron. *Surface Encounters: Thinking with Animals and Art*. Minneapolis: University of Minnesota Press, 2011.

Brower, Matthew. *Developing Animals: Wildlife and Early American Photography*. Minneapolis: University of Minnesota Press, 2011.

Burt, Jonathan *Animals in Film*. London: Reaktion Books, 2002.

————."John Burger's 'Why Look at Animals?': A Close Reading." *Worldviews: Global Religions, Culture, and Ecology* 9, no. 2 (2005): 203–18.

Caffo, Leonardo, and Valentina Sonzogni. *An Art for the Other: The Animal in Philosophy and Art*. Trans. Sarah De Sanctis. Brooklyn, NY: Lantern Books, 2015.

Cherry, Elizabeth. 2016. "The Pig That Therefore I Am": Visual Art and Animal Activism." *Humanity and Society* 40, no. 1 (2016): 64–85.

Cronin, J. Keri. *Art for Animals: Visual Culture and Animal Advocacy, 1870–1914*. University Park: Pennsylvania State University Press, 2018.

Eisenman, Stephen F. *The Cry of Nature: Art and the Making of Animal Rights*. London: Reaktion Books, 2013.

Freeman, Carol, Elizabeth Leane, and Yvette Watt, eds. *Considering Animals: Contemporary Studies in Human-Animal Relations*. Burlington, VT: Ashgate, 2011.

Hinson, Joy. *Goat*. London: Reaktion Books, 2015.

Kalof, Linda. *Looking at Animals in Human History*. London: Reaktion Books, 2007.

Kalof, Linda, Joe Zammit-Lucia, Jessica Bell, and Gina Granter. "Fostering Kinship with Animals: Animal Portraiture in Humane Education." *Environmental Education Research* 22, no. 2 (2016): 203–28.

Kalof, Linda, Joe Zammit-Lucia, and Jennifer Rebecca Kelly. "The Meaning of Animal Portraiture in a Museum Setting: Implications for Conservation." *Organization and Environment* 24, no. 2 (2011): 150–74.

Malamud, Randy. *An Introduction to Animals and Visual Culture*. New York: Palgrave Macmillan, 2012.

McHugh, Susan. *Dog*. London: Reaktion Books, 2004.

Mills, Brett. "Television Wildlife Documentaries and Animals' Right to Privacy." *Continuum* 24, no. 2 (2010): 193–202.

Mizelle, Brett. *Pig*. London: Reaktion Books, 2011.

Potts, Annie. *Chicken*. London: Reaktion Books, 2012.

————, ed. *Meat Culture*. Boston: Brill, 2016.

Rogers, Katharine M. *Cat*. London: Reaktion Books, 2006.

Velten, Hannah. *Cow*. London: Reaktion Books, 2007.

Watt, Yvette. "Artists, Animals and Ethics." *Antennae: The Journal of Nature in Visual Culture* 19 (2011): 62–72.

Walker, Elaine. *Horse*. London: Reaktion Books, 2008.

Zammit-Lucia, Joe. "Practice and Ethics of the Use of Animals in Contemporary Art."

In *The Oxford Handbook of Animal Studies*, ed. Linda Kalof, 433–55. New York: Oxford University Press, 2017.

Zammit-Lucia, Joe, and Linda Kalof. "From Animal Rights and Shock Advocacy to Kinship with Animals." *Antennae* 23 (2012): 98–111.

ANIMAL EMOTIONS AND COGNITION

Balcombe, Jonathan. *Second Nature: The Inner Lives of Animals*. New York: Palgrave Macmillan, 2010.

———. *What a Fish Knows: The Inner Lives of Our Underwater Cousins*. New York: Scientific American / Farrar, Straus, and Giroux, 2016.

Bekoff, Marc. *The Emotional Lives of Animals: A Leading Scientist Explores Animal Joy, Sorrow, and Empathy—and Why They Matter*. Novato, CA: New World Library, 2007.

———. *Why Dogs Hump and Bees Get Depressed: The Fascinating Science of Animal Intelligence, Emotions, Friendship, and Conservation*. Novato, CA: New World Library, 2013.

Darwin, Charles. *The Expression of the Emotions in Man and Animals*. Ed. Joe Cain and Sharon Messenger. New York: Penguin Classics, 2009.

Daston, Lorraine, and Greg Mitman, eds. *Thinking with Animals: New Perspectives on Anthropomorphism*. New York: Columbia University Press, 2005.

Hatkoff, Amy. *The Inner World of Farm Animals: Their Amazing Social, Emotional, and Intellectual Capacities*. New York: Stewart, Tabori, and Chang, 2009.

King, Barbara J. *Personalities on the Plate: The Lives and Minds of Animals We Eat*. Chicago: University of Chicago Press, 2017.

———. *How Animals Grieve*. Chicago: University of Chicago Press, 2013.

Masson, Jeffrey Moussaieff. *The Pig Who Sang to the Moon: The Emotional World of Farm Animals*. New York: Ballantine Books, 2003.

Morell, Virginia. *Animal Wise: The Thoughts and Emotions of Our Fellow Creatures*. New York: Crown, 2013.

Safina, Carl. *Beyond Words: What Animals Think and Feel*. New York: Henry Holt, 2015.

de Waal, Frans. *Are We Smart Enough to Know How Smart Animals Are?* New York: W. W. Norton, 2016.

FARM SANCTUARIES

Baur, Gene. *Farm Sanctuary: Changing Hearts and Minds about Animals and Food*. New York: Touchstone, 2008.

Baur, Gene, and Gene Stone. *Living the Farm Sanctuary Life: The Ultimate Guide to Eating*

*Mindfully, Living Longer, and Feeling Better Every Day*. New York: Rodale, 2015.

Brown, Jenny, and Gretchen Primack. *The Lucky Ones: My Passionate Fight for Farm Animals*. New York: Avery, 2012.

Donaldson, Sue, and Will Kymlicka. "Farmed Animal Sanctuaries: The Heart of the Movement? A Socio-Political Perspective." *Politics and Animals* 1 (2015): 50–74.

Hart, Sharon Lee. *Sanctuary: Portraits of Rescued Farm Animals*. Milan, Italy: Edizioni Charta, 2012.

Jones, Miriam. "Captivity in the Context of a Sanctuary for Formerly Farmed Animals." In *The Ethics of Captivity*, ed. Lori Gruen, 90–101. New York: Oxford University Press, 2014.

No Voice Unheard, ed. *Ninety-Five: Meeting America's Farmed Animals in Stories and Photographs*. Santa Cruz, CA: No Voice Unheard, 2010.

Stevens, Kathy. *Animal Camp: Reflections on a Decade of Love, Hope, and Veganism at Catskill Animal Sanctuary*. New York: Skyhorse, 2010.

## CREATIVE INFLUENCES

Adams, Shelby Lee. *Salt & Truth*. Richmond, VA: Candela Books, 2011.

Avedon, Richard. *Richard Avedon Portraits*. New York: Harry N. Abrams / Metropolitan Museum of Art, 2002.

Barthes, Ronald. *Camera Lucida: Reflections on Photography*. Trans. Richard Howard. New York: Farrar, Straus, and Giroux, 2002.

Bidaut, Jane Hinds. *Animalerie*. Austin: University of Texas Press, 2004.

Carter, Keith. *A Certain Alchemy*. Austin: University of Texas Press, 2008.

Coe, Sue. *Cruel: Bearing Witness to Animal Exploitation*. New York: OR Books, 2012.

———. *Dead Meat*. New York: Four Walls Eight Windows, 1995.

Doty, Mark. *Dog Years: A Memoir*. New York: HarperCollins, 2007.

Dumas, Charlotte. *Anima*. Exhibition catalog. Washington, DC: Corcoran Gallery of Art, 2012.

Hujar, Peter. *Portraits in Life and Death*. New York: DaCapo, 1976.

Hujar, Peter, and Klaus Kertess. *Peter Hujar: Animals and Nudes*. Santa Fe, NM: Twin Palms, 2002.

Johnstone, Shannon. *Landfill Dogs*. San Francisco: Blurb, 2017

McArthur, Jo-Anne. *We Animals*. Brooklyn, NY: Lantern Books, 2014.

Tucker, Anne, and Richard Misrach. *Crimes and Spendors: The Desert Cantos of Richard Misrach*. Boston: Bullfinch Press / Museum of Fine Arts Houston, 1996.

Sontag, Susan. *On Photography*. New York: Picador, 1973.

———. *Regarding the Pain of Others*. New York: Picardor, 2003.

# Biographies

AUTHOR

ISA LESHKO is an artist whose work examines themes relating to animal rights, aging, and mortality. She has exhibited her work widely in the United States and has received fellowships from the Bogliasco Foundation, the Culture & Animals Foundation, the Houston Center for Photography, the Millay Colony for the Arts, and the Silver Eye Center for Photography. Her images have been published in the *Atlantic*, the *Boston Globe*, *Frankfurter Allgemeine Sonntagszeitung*, the *Guardian*, *Harper's Magazine*, the *New York Times*, and *Süddeutsche Zeitung*. Isa currently lives in Salem, Massachusetts, with her life partner, Matt Kleiderman, and their cats, Alfred and Higgins.

CONTRIBUTORS

GENE BAUR is the president and cofounder of Farm Sanctuary and has been hailed as "the conscience of the food movement" by *Time* magazine. A pioneer in undercover investigations, he has traveled extensively since the mid-1980s, campaigning to raise awareness about the abuses of animal agriculture and the high costs of our cheap food system. Gene has published two national bestsellers, *Farm Sanctuary: Changing Hearts and Minds about Animals and Food* and *Living the Farm Sanctuary Life*, which he coauthored with Gene Stone. He is a longtime vegan, marathon runner, and Ironman triathlete and was recently named one of Oprah Winfrey's SuperSoul 100 Givers.

SY MONTGOMERY is a naturalist, documentary scriptwriter, and author who writes for adults as well as children. She is author of twenty acclaimed books, including *New York Times* bestsellers *The Good Good Pig* and *The Soul of an Octopus: A Surprising Exploration into the Wonder of Consciousness*, which was a finalist for the 2015 National Book Award for Nonfiction. The recipient of numerous honors, including lifetime achievement awards from the Humane Society and the New England Independent Booksellers Association, she lives in New Hampshire with her husband, a border collie, and a flock of chickens.

ANNE WILKES TUCKER is the curator emerita of the Museum of Fine Arts, Houston, having, in 1976, become founding curator of the photography department for which she acquired 35,000 photographs made on all seven continents.

She curated or cocurated more than 40 exhibitions, most with accompanying catalogs, including surveys on the Czech Avant-garde, the history of Japanese photography, and the history of war photography. She has also contributed articles to more than 150 magazines, books, and other catalogs and has lectured throughout North and South America, Europe, and Asia. Her honors, fellowships, and awards include being selected as "American's Best Curator" by *Time* magazine in 2001.

# Acknowledgments

First and foremost, I want to thank each of the animals I photographed for this book. I am tremendously grateful for their patience, trust, and friendship. Their lives inspire me daily.

Thank you to Farm Sanctuary's National Shelter Director Susie Coston, whose guidance and encouragement was instrumental to the development of this project. When I first visited Farm Sanctuary, country life was utterly foreign to me. I was so clueless that I didn't even know how to unlatch a farm gate. Nonetheless, Susie took me seriously and was incredibly generous with her time. I have learned so much from her through the years, particularly about the inner lives of farm animals.

I am also grateful to all of the sanctuary employees I met while working on this project, including Johnny Braz, Hervé Breuil, Jenny Brown, Amanda Carner, Lynn Cuny, Gabriella Desantis, Gita Devi, Todd Friedman, Laura Henderson, Armand Luke Hess, Becca Hines, Erin Howard, Susan Kayne, Katherine Keefe, Dani Kice, Dawnell Kilbourne, Indra Lahiri, Jeff Lydon, Christine Morrissey, Tara Oresick, Stephanie Perciful, Kate Powell, Sophia Rivers, Cyndy Roseman-Puccio, Kathy Stevens, Nick Ugliuzza, Logan Vindett, Tony Vindett, Karen Wagner, Susan Wagner, Debra White, and Kerrie Wooten. I am in awe of these dedicated men and women. Their jobs are physically and emotionally grueling: they work long hours outdoors in extreme temperatures and they witness firsthand the horrific abuse farmed animals endure. Death and loss are fixtures in their lives. Yet they are unwavering in their devotion to the animals in their care. A special shout out also goes to Laura Henderson and Indra Lahiri, who hosted me in their lovely homes during my visits to Pasado's Safe Haven and Indraloka Animal Sanctuary.

Thank you to the following people who allowed me to photograph their beloved companion animals for this project: Beverly Alba, Mary Beth Boland, Jonathan Burnham and Joe Dolce, Susan Burnstine, Pam Hovas, and MariJo Niles Sena. Thank you also to Two Hands Four Paws in Los Angeles, California, for allowing me to photograph their canine patients for this project.

I am indebted to my agent Elizabeth Kaplan for finding the perfect home for this book and for her encouragement and assistance as I worked on this project.

I was blessed to have not one but two gifted editors for this project. Thank you to Christie Henry for being this book's first champion at the University of Chicago

Press and for a joyful collaboration during the planning stages of the book. I truly felt that the sky was the limit and I am so grateful for that. Thank you to Susan Bielstein for patiently editing numerous drafts of my essays, and for her spot-on feedback and invaluable guidance. I am also deeply grateful to the rest of the University of Chicago Press team for the respect and care that they brought to this project: Jenni Fry, Jill Shimabukuro, Levi T. Stahl, and James Whitman Toftness. Thank you also to the anonymous readers who reviewed my manuscript. Their tough love was exactly what this book needed.

I am thankful to the talented contributing writers—Gene Baur, Sy Montgomery, and Anne Wilkes Tucker—for their thoughtful engagement with my work. I am honored by their enthusiasm for this project and their beautifully written essays.

Thank you to the galleries that represent my work, especially for taking a chance on me when I was just beginning my career: Richard Levy, Viviette Hunt, and Chelsea Wrightson of the Richard Levy Gallery in Albuquerque, New Mexico, and Elizabeth Corden and Jan Potts of the Corden|Potts Gallery in San Francisco, California.

I do not even know where to begin in thanking Paul and Patty Sneyd and the team at Panopticon Imaging in Rockland, Massachusetts, including Elizabeth Ellenwood, Eric Evans, Shannon McDonald, Chris Mulready, Nick Schietromo, and Bruce Wahl. We have spent countless hours working together on the images in this book, and I'm grateful for their good humor, commitment to impeccable quality, and respect for my vision. Collaborating with them has been a constant source of joy over the last decade, and I have learned so much from them.

Thank you to my friends who reviewed drafts of my essays for this book: Erica Cavanagh, Debra Curtin, Daniel Dehn, Laurie Granieri, and Stephen Perloff. My writing is considerably better because of their feedback.

My dear friend Debra Curtin grasped this project's potential before I had even appreciated it. I am tremendously grateful for her encouragement and for the many stimulating discussions we have had relating to my work and to animal ethics.

Thank you to the following people who have provided encouragement, guidance, and friendship throughout my career: Ri Anderson, David Bram, Leslie K. Brown, Jonathan Burnham, Brian Paul Clamp, Stacey Clarkson, Trudy Cohen,

Catherine Couturier, Ron Cowie, Julian Cox, Keri Cronin, Tony Decaneas, Jason Dibley, Caroline Docwra, Bevin Bering Dubrowski, Seraphina Erhart, Ellen Fleurov, Roy Flukinger, Diana Gaston, Lucie Gilman, Hamidah Glasgow, James Goncalves, Kristen Gresh, Aaron Gross, Lori Gruen, Holly Hughes, Jeff Johnson, Linda Johnson, Nick Johnson, Mary Shannon Johnstone, Barbara J. King, Stella Kramer, Clair Linzey and the Reverend Professor Andrew Linzey of the Oxford Centre for Animal Ethics, Jo-Anne McArthur, Janet McCracken, Martin McNamara, Naomi Mindlin, Bruce Myren, Rowena Otremba, Stephen Perloff, Laura Pressley, Christopher Rauschenberg and Janet Stein, Mark and Patience Sandrof, Julie Saul, Aaron Schmidt, Michael Sebastian, Rebecca (Becky) Senf, Salise Shuttlesworth, George Slade, Gordon Stettinius, Cynthia Suprenant, Mary Virginia Swanson, Amber Terranova, Paula Tognarelli, Kate Ware, William Williams, Clint Willour, and Natalie Zelt. Thank you also to collectors of my work. Your support through the years helped fund this project.

I am grateful to Mark and Angela Walley of Walley Films for producing a beautiful short documentary about this project in 2011. Their film generated immense visibility for my work, which opened many doors for me.

Several of the images that appear in this book were made possible by funding from the Culture & Animals Foundation, an organization dedicated to advancing animal advocacy through intellectual and artistic expression. In addition, this project has received funding from the Houston Center for Photography in Houston, Texas, and the Silver Eye Center for Photography in Pittsburgh, Pennsylvania.

I wrote an early draft of my introduction to this book and created several images for this project while I was an artist in residence at the Millay Colony for the Arts in Austerlitz, New York. My warm gratitude goes to the Millay Colony staff (Caroline Crumpacker, Calliope Nicholas, and Donna Wenzel) and also to the Jean and Louis Dreyfus Foundation for generously funding my residency. Thank you also to my fellow artists in residence (aka "Michael and the Millays"): Erica Cavanagh, Michael Harrison, Tricia Keightley, Monica Ong Reed, and Adrian Shirk Sweeney.

I finished my manuscript while in residence at the Bogliasco Foundation in Bogliasco, Italy. Thank you to the foundation staff for their support, especially Ivana Folle, Raffaella Folle, Laura Harrison, Arielle Moreau, Valeria Soave, Danilo Taffurelli, and Fabio Toracca. Thank you also to my fellow artists in residence and

their life partners who accompanied them to Bogliasco: John Comazzi, Caoilinn Hughes and Paul Behrens, Len and Ramona Jenkin, Sandra Parker, James Shapiro and Mary Cregan, Stacey Steers and David Brunel, and Kees Tazelaar and Marianne Dekker. My month on the Ligurian Coast was truly a dream come true.

Finally, I am grateful to my family: my sister Mia Sena, who was like a second mom to me when I was a child and is now a close friend, her husband Ralph Sena, and my niece Francesca Sena, and those whom I wish were alive to celebrate this book's publication—Mom, Dad, Grandma Margaret, Grandpa Donnie, and Uncle Frank.

Words cannot adequately convey my love and gratitude for my incredibly supportive life partner of more than twenty-five years, Matt Kleiderman, and our feline family: Armand, Gypsy, Niccolo, Katarina, Alfred, and Higgins.